MW00613830

THE MUSEUM

THE MUSEUM

A Short History of Crisis and Resilience

Samuel J. Redman

NEW YORK UNIVERSITY PRESS

New York

NEW YORK UNIVERSITY PRESS
New York
www.nyupress.org

References to Internet websites (URLs) were accurate at the time of writing.
Neither the author nor New York University Press is responsible for URLs
that may have expired or changed since the manuscript was prepared.

Cataloging-in-Publication data is available from the publisher.

New York University Press books are printed on acid-free paper, and their
binding materials are chosen for strength and durability. We strive to use
environmentally responsible suppliers and materials to the greatest extent
possible in publishing our books.

Manufactured in the United States of America

10 9 8 7 6 5 4 3 2 1

Also available as an ebook

CONTENTS

Introduction

On a cold and clear afternoon in January 1865, a roaring fire swept through the Smithsonian Institution. The flames ripped through the building and charred the museum's castle as dazed soldiers and worried citizens looked on. The ceiling caved in. Walls fell. Valuable objects inside were swallowed by flames and destroyed. Unique paintings depicting scenes from around the world and rare scientific objects were lost. "The contributions of the Institution to science and art in this country have been most important," read the *New York Times* the following day, "and the destruction of so many of its fine collections will be viewed as a national calamity."[1] The core of the building had been hollowed, gutted by fire and smoke. Without a doubt, the fire represented a nearly unprecedented cultural crisis in North America.

The flames at the Smithsonian can be read, at least in part, as an omen of things to come for museums in the United States.[2] Beset by challenges ranging from pandemic and war to fire and economic uncertainty, museums have sought ways to emerge from crisis periods stronger than before, occasionally carving important new paths forward in the process. Hampered by various problems, museum leaders each responded differently to the challenges at hand.

Outside voices and important criticism have further prompted vital changes. As often as institutions have transformed, however, they also find themselves stubbornly embedded into a larger culture.[3] Tensions emerged as cultural institutions that were so deeply committed to preservation were forced to confront changes. Blind spots and biases have at times led to critical mistakes. Museums, it seemed, could never fully separate themselves from the world in which they existed. Steady and principled leadership guided by clear vision, firm commitments to guiding missions, collaboration, prudent financial management, innovation, and adept disaster responses have all paid dividends for museums over the long run. Whenever the flames of crisis engulfed museums, uncertainty tended to surround the future, with fascinating and important developments often following these pivotal moments.

The Smithsonian, for example, was not destroyed by the fire that had devastated its building and many of its early collections. To this point, the castle had been packed with a mishmash of poorly selected and haphazardly preserved materials crowded into the same rooms that were also filled with many actual national treasures. After the fire, the museum began a long road to recovery. Perhaps the museum had even been weighed down by the many ghosts of its past. Legislators voted to support the Smithsonian through new government dollars. The museum rebuilt charred exhibit halls, redoubled its commitment to scientific publications, and unpacked boxes of new collections brought to Washington, DC, by the train carload. Within a few years, the museum

was advancing well beyond where it had been at the time of the fire. By 1883, electric lights shined in the galleries, and the museum had grown to host twenty-eight curators and thirty additional scientific staff. It is estimated that the rapidly expanding collection already held nearly two and a half million objects. In 1897, the museum met growing demand by constructing new exhibit halls for visitors to explore. By 1900, more than 225,000 people visited the museum. The nineteenth-century Smithsonian, like many museums facing a crisis, managed to emerge stronger, although the best methods to move forward were not always clear to historical actors at the time. When the institution opened a large and popular new natural history museum on the National Mall in spring 1910, the destructive fire forty-five years earlier mostly served as a reminder to construct fireproof museum buildings. The history of museums in the United States, in no small part, is a story of crisis and response, death and rebirth, an evolution over time guided by and responding to larger trends in US and global society.

A *crisis*, at least according to my handy Merriam-Webster dictionary, is "an unstable or crucial time or state of affairs in which a decisive change is impending." We often think of a crisis as connected to impending doom rather than any sort of positive change—think of expressions like *financial crisis* or *energy crisis*. But crisis is also linked to other kinds of change, such as a "turning point *for better or worse* in an acute disease or fever" (emphasis mine).[4] A crisis, in this way, is more a moment of truth or an important crescendo than a dark path toward a certain calamity.

3

Even returning to the basic concept of crisis, therefore, might help us to rethink the relationship between possible threats to and the basic function of museums as a space for preservation. The fires, floods, financial meltdowns, and calls for change connected to vocal protests have often been named as "crisis" situations for museums. This book asks what that really means and how museums might rethink these crisis stories more generally. If crises truly represent critical turning points for museums and other cultural institutions, should we not pay more attention to them as a historical phenomenon?

At crisis moments, museums have often been forced to confront essential questions. What are our main priorities? Whom do museums serve? How do cultural institutions continue to survive with curtailed operations? What operations are deemed "essential" in times of reduced staffing and stripped-back exhibitions and plans for collecting expeditions? How might museums use these moments of crisis most productively for reflection and improved access to serve larger communities? What about when the communities surrounding cultural institutions are themselves in crisis? How should a museum respond then? How might museums balance their varied roles in public education, research, and preservation? When examined in retrospect, have museums done everything they might do to prepare and respond to disasters and crises of various kinds?

In part, these questions are about asking what a museum even is to begin with, what it has been at points during the

past century, and what it should be moving forward. As a former museum professional and cultural historian interested in museum history, I have written this book to offer a version of the story of how museums have successfully and unsuccessfully navigated several major crisis moments in US history. Along the way and in the book's concluding pages, I offer my interpretive assessment as to how museums faced these challenges and try to wrestle with these observations to offer potential ideas for museums, policy makers, and activists moving forward. I highlight how complex many of these challenges have been, and while this treatment of museum history does not offer easy answers, some clear trends about museums and crises do emerge.[5]

Crisis moments have not always been dealt with effectively or understood accurately in retrospect. Traditional museum leadership structures have not always proven adept at responding to unforeseen challenges. This is in some sense predictable; how can you possibly prepare for a challenge that you cannot yet foresee? Without enough distance and context, can we fully understand the events shaping museums and other cultural institutions? And yet examples in which more forward-thinking, collaborative, or creative solutions have been embraced stand out as providing important guides for helping us rethink museums today and in the future. Other examples prove less inspiring. Museums have also sometimes proven themselves to be too locked into existing political and social structures to change in a manner sufficient to face a growing crisis. In light of this challenge

in particular, how might we rethink the troubled histories of colonialism, power, and politics for museum history?

By the time of the Smithsonian fire, it was estimated that the United States was already home to at least 327 museums.[6] Today, thousands of museums operate across the United States. Historically, these institutions have gathered, organized, and displayed the world as conveyed through objects, the material evidence of natural or manmade phenomena. Museums can be large or small, public or private, and speak to enlightening ideas that engender sympathy toward the planet and the humans who occupy it. Or, more cynically, they can elevate particular types of social control and dubious truths presented through ideological means. Museums, which sometimes occupy centuries-old buildings and hold objects created or uncovered long ago, intrinsically suggest historical continuity. Nevertheless, they remain firmly bound to the evolving societies surrounding them. In the late nineteenth century, museums became some of the most consequential spaces in US cultural life as the nation took its place in the world. This was especially true in rapidly growing cities keen to build museums as a sign of their regional importance. Museums also became more specialized, increasingly focused on art, natural history, and history. They worked to rigorously define their operations in these frameworks.[7]

When writing about the history of museums, most scholars have focused on their institutional origins in the nineteenth century.[8] Extending this history into the twentieth and twenty-first centuries is crucial. If museums have been historically and continue to be one of the most popular edu-

cational resources for the public in the United States, then how they have responded to past challenges matters a great deal in shaping our contemporary cultural landscape. Thinking about museums and crisis moments suggests something about what our priorities have been and how we might better respond to the unpredictable challenges ahead when considering the same or similar cultural institutions. It also offers insights into what people thought was worth preserving at the time and suggests something about the social and economic structures translating ideas into reality.

Museums have historically had a tendency, at least in public documents, to celebrate positive visions of expansion, new additions, and improvements even in moments of great stress. Some events, such as the Smithsonian fire and, later, the Great Depression, have proven to be pivotal turning points for museums because they prompted an institutional change. Other events, including the 1918 influenza epidemic and the 1970 art strike, have had less of an effect than they might have, buried in contexts jam-packed with other divergent happenings. Nevertheless, these episodes were seen as critically important at the time. These events have largely been overlooked in their instructive significance for the adverse situations that museums continue to face today.

This book describes the many storms that museums have encountered and how different approaches have helped them to survive these tempests and grow. The experiences considered from our past offer clues that can help us learn from critical moments. Beginning with the flu pandemic coinciding with World War I, the pages to follow explore some of the

many pitfalls facing US museums during the past century or more. Stretching through the Great Depression, World War II, and the many debates about museums and their futures in the second half of the twentieth century, this book argues that museums should more critically reflect on their histories to better address challenges they face in the present and prepare for others that may lie ahead in an uncertain future.

War, Cold, Unrest, Strikes, and Epidemics

In a dramatic and surprisingly candid public report in 1920, the president of the American Museum of Natural History (AMNH) in New York reflected on where the museum stood in challenging times. He wrote, "The past few years of war, cold, unrest, strikes and epidemics of infantile paralysis and influenza have told severely on Museum attendance, but the year 1919, it is hoped can be considered as an approach to normal."[1] The years between 1917 and 1920 proved to be wildly uncertain and rapidly changing, even as many museum leaders expressed upbeat confidence about the future.

US involvement in World War I proved relatively brief, starting with a war declaration in April 1917 and ending with an armistice agreement in November 1918. As the war ended, the United States was experiencing the peak death rate resulting from the 1918 influenza pandemic. Because the Spanish press reported in a purportedly neutral manner on the public health crisis, the influenza strain became widely known as the "Spanish flu." The rates of infection and death, however, would spike again the following spring, especially in February and March 1919. Some museums, as illustrated in the AMNH report, directly acknowledged the influence of the deadly flu virus on their attendance and operations.

Other museums went to great lengths to point to other factors in explaining away similar dips in turnstile figures.

Special exhibits, experiments with expanded open hours, returning soldiers, and popular education programs all served as conflating factors making it difficult to measure, exactly, the effect of the influenza pandemic on museums in the United States during this era. As the pandemic was quietly raging, widespread unrest and economic uncertainty created an undercurrent leading to a record number of strikes and worker protests taking place in cities across the nation. In the midst of the era's uncertainty, the moment was clearly presenting a bevy of unique and worrying challenges. Museum attendance was down, staffers were struck by illness, and exhibit plans were altered. In museum leaders' most revealingly honest moments, they acknowledged that recent history had been arduous and at times unsettling.

Certainly, museums in the United States did not experience the Great War to the degree their counterparts in Europe did. Growing fears about shelling and possible looting led to the Louvre's being shut down in August 1914. All but the heaviest statues were temporarily moved from the museum for safekeeping. The British Museum, meanwhile, closed to the public somewhat later in the war, shuttered in March 1916. The Smithsonian Institution and many other US museums large and small, obviously less vulnerable to attack, on the other hand, stayed open for the war's duration.

A wave of museum building took place during the Gilded Age and Progressive era across the United States. Major natural history museums emerged in cities like New York, Chi-

cago, and Washington, DC. The Smithsonian Institution was also home to a major art museum, rivaled in importance by major public art museums in New York, Boston, Philadelphia, and Chicago. Historical societies, too, had emerged in many states by this time, although their popular exhibitions and libraries reported more modest visitor numbers than did major urban art and natural history museums, which were already drawing visitors by the thousands, in some cases hundreds of thousands, each year.

The global influenza pandemic that hit in 1918, however, was so unanticipated, widespread, and devastating that its short-term effect on museums rivaled that of the war itself. Wedged between the dramatic events of World War I and the Roaring Twenties, the historical memory of how museums and other cultural institutions were affected by the 1918 influenza has faded away to a remarkable degree.

To tell this story, I rely on the many public documents that museums produced and published themselves, especially the annual reports updating their trustees and donors on the progress made during the year. Reading these documents critically and against the grain, I address two questions: How did museums respond to the 1918 influenza pandemic? Furthermore, why is such a consequential global event so largely forgotten in museum history? Historical newspapers add some additional details to this history, but reporting on influenza in museums as a public space was relatively limited in this era.

The story begins somewhat earlier, with museums at the dawn of the twentieth century. The United States, especially

urban centers jostling for national and regional influence, began building and opening museums of art, natural history, and history in the late nineteenth and early twentieth centuries. In 1870, the Metropolitan Museum of Art was incorporated in New York City, moving to its current location in 1880. Following the 1893 World's Columbian Exposition, a major natural history museum was organized in Chicago. The Brooklyn Museum (then the Brooklyn Institute) opened a grand new building in 1897. The Newark Museum of Art followed in 1909 and the Montclair Art Museum in 1914. A large new building on the National Mall in Washington, DC, for the Smithsonian's National Museum of Natural History opened in March 1910, attracting more than four hundred thousand visitors annually by 1916–1917. Museums of all kinds—ranging from small traveling dime museums with dubious exhibits to major and regional art and natural history museums—were gaining momentum as they became popular with visitors. The catastrophic 1865 fire at the Smithsonian was by now a distant memory. Museums were poised to stride into an exciting future.

Museums before World War I

In the years leading up to World War I, several important debates about museums were taking place.[2] Ideas about the place of material observation in scientific research were shifting. Following calls for greater access for working people, museums in this era were gradually opening their doors on Sunday, the only day off from work for the majority of

workers in this era.[3] Museums had generally grown alongside literacy rates, which expanded dramatically during the nineteenth century. Public libraries, too, had emerged across the country as important institutions enabling access to information previously unavailable to the masses.

"During this period of time," writes the curator John Simmons, "museums were widely seen as institutions integral to raising the level of education of the public."[4] Urban museums growing in size and number attracted a great deal of attention, but the number of historic house museums (many supported by new local historical societies) also grew tremendously as roads and railroad access improved.[5] Trains also brought agricultural exhibits to rural areas.[6] Between 1860 and 1914, the number of museums in the United States nearly doubled to six hundred.[7] If there was a museum crisis at the dawn of the twentieth century, it was thought to be the crushing lack of space facing many museums as they were filled to the brim with growing collections.[8]

A few automobiles were starting to appear, but most people took some form of public transportation (train, subway, or streetcar in many cases) to major urban museums. Others simply walked. Museums were starting to show a greater degree of commitment to tracking the number of visitors who walked through their doors. Attendance was on the rise overall. Visitors were eager to see wonders from around the world displayed in dioramas and under glass cases. Dinosaur skeletons were dramatically mounted at several major museums, and expeditions were under way in the US West to gather even more fossils.[9] In many parts of the country, seg-

regationist laws denied equal access to public spaces, including museums, for vast numbers of people of color. Others, too, were denied visits to museums. Many people lacked the economic means or time away from responsibilities to make visits a possibility. And yet, at least for those afforded the opportunities that were denied to others as a result of racism and economic disparity, museums were overall becoming more popular in the United States.

Opening a museum and amassing collections were one thing, but keeping these materials organized was another thing entirely. When a new assistant secretary arrived at the Metropolitan Museum of Art in New York, he was "appalled by the lack of a system that he found."[10] The museum only had one typewriter and one telephone.[11] Not far away in New Jersey, a library and museum director named John Cotton Dana found himself similarly appalled. There were so few books available on how to properly organize and manage a modern museum that he decided to write one. His 1917 book, *The New Museum*, offered bold visions responding to this need for new information about museum management. Dana reflected that "there is now a wide-spread, if not intense and popular, demand for suggestions on museum founding and on the elements of museum management."[12]

Museum leaders in this era tended to show a deepening commitment to professionalization, part of a broader trend touching many cultural institutions in this era. Dana added to this expanding sentiment and the literature responding to it, pushing museums to think differently about their approach. Museums had invested too much in collecting and

not enough in public education, he argued. Acquiring a spectacular new work of art might feel like the right thing at the time, but it was costly and might have little practical value to the wider community if not used to its full potential. Even as museum leaders continued to carry on expansion of their permanent collections, many were starting to listen to calls to reorient their overall emphasis.

When imagining a new museum based on these shifting principles, Dana reflected, "One of the wider purposes of our museum is to make life better worth living, not by adding luster to riches and creating pleasurable reactions to the avowedly aesthetic; but by encouraging all to discover possibilities of agreeable emotions in the contemplation of things."[13] Dana did not wish to deny the beauty of art or people's inherent pleasure response in reacting to viewing it up close. He also wanted museums to strive for more. Art should be studied, not worshiped, he argued. Artworks, he added, "should be preserved that they may help us, not that they may amaze and confound us. . . . Above all, we should study them with the purpose of learning from them."[14]

Following the push from Dana and others in this era, museums were also working to become more direct in their response to recent and newsworthy events. While many cultural institutions attempted to remain neutral in political debates, some began reorienting exhibits to address contemporary issues. In response to widespread tuberculosis prevalent in the early twentieth century, the Smithsonian and AMNH developed exhibits on the disease, which they advertised using big signs reading, "Don't Spit."[15] The exhibits

attracted thousands each day who filed into the museum by waiting in long, cramped lines. The exhibit's popularity, while probably good for information literacy, also potentially created vectors to further spread disease. Nevertheless, highly touted public health exhibits were widely deemed successful in this era.

Generally speaking, one reason why the war seemed to have an outsized influence on museum narratives was the fact that cultural institutions began thinking about its many possible implications on staff and operations well before the official US entry into the conflict.[16] With war on the horizon, some staffers began leaving museums in Canada and the United States to join the active service, while others started to think about retooling their work to contribute to a possible war effort. Even before the war officially began, tempting job offers from war-related industries started luring away some staffers with high-paying jobs.[17] Changes were clearly afoot.

Museums during World War I

"In addition to the usual activities and routine duties," reads one Smithsonian report, "the scientific staff of the Institution continued, until the day of the signing of the armistice, to assist the Government in every way possible toward the successful prosecution of the war. The Museum staff were in constant touch with Army and Navy officials."[18] At least according to people writing about cultural institutions at the time, World War I resulted in a major shift in thinking about museums, their purpose, and operations in this era. This

transformation, however, was largely viewed as temporary and tied to the war and its outcome.

When the United States entered the war in April 1917, many Americans volunteered. The explosion of volunteerism across much of US society was especially apparent in museums, where several steps were immediately taken to help the war effort. Skills in building, chemistry, work with textiles, and other areas were now suddenly in demand, and many staffers were stepping away from their museum work to help with the war effort.

Levels of commitment and coordination were uneven, and museums in capitals and urban centers like New York and Washington, DC, experienced these changes more intensely than they were felt in many other places. Many shifts, including the widespread temporary suspensions in research and educational programs, were self-imposed by museums on a volunteer basis.

Other suspensions, however, resulted from shifting "manpower" during the war. In Philadelphia, where a major art museum was conjoined to an art school, sixty students from the Textile Department were called by the US government to become fabric inspectors for the war's duration.[19] With uniforms required by the millions to outfit US troops, people with expertise in working with fabrics were called to duty. Fabrics were also used in other war equipment including parachutes and aircraft.

Though museum attendance was generally trending up, in some places a clear slowdown took place early in the war. In 1916, for example, 339,430 visitors traveled to Philadelphia's

art museum, whereas this number was down to 318,471 by 1917.[20] Both attendance and membership were down at the Brooklyn Museum. Appealing to the public for new memberships seemed less patriotic in a time when other needs seemed more pressing.[21]

In this era, many people assumed that the Great War would be the global event most significant for cultural institutions. While World War I certainly had a pronounced social and cultural significance in Canada and the United States, the war's effect was felt less forcefully in North America than in Europe and elsewhere around the world. Nevertheless, some US museum operations were immediately curtailed as staff departed and travel became restricted. The year 1914 was the first since the Field Museum's founding that it did not sponsor an anthropology or archaeology collecting expedition. While the museum did sponsor one curator's work in India in 1915, the museum would not return to regularly sponsoring new expeditions until 1922, around the time when it also opened a new building.[22]

There were, however, exceptions. Starting in 1916, Childs Frick, the son of the steel magnate Henry Frick, used his wealth to sponsor AMNH paleontology expeditions. The AMNH further sponsored expeditions to collect birds and mammals in Africa and Asia in 1918 and 1919. An African expedition sponsored by the Smithsonian between 1919 and 1920 returned with one thousand botanical specimens and sixteen hundred live plants to be replanted in the United States. These examples notwithstanding, the dangerous conditions created by global war and pandemic had curtailed

or canceled many plans to engage in museum collecting expeditions.

One reason accounting for the added danger in launching collecting expeditions was the rise of deadly German submarine operations, making Atlantic Ocean crossings especially perilous for British, Canadian, and US ships during the war years. An expedition to collect birds in Europe or mammals in Africa now meant putting one's life on the line to an even greater degree than before. With fewer outward expeditions now taking place during the war after the summer in 1914, many institutions in North America started to look inward.[23] Exhibitions might be retooled some and existing specimens written about, but the work of gathering new collections was surely to change for a stretch.

In an April 1918 article published in the *Scientific Monthly*, the Canadian scholar Harlan I. Smith argued, "The work of museums in war time, instead of being stopped or curtailed to effect economy, should be speeded up and directed from the usual paths into those that will help most to win battles, to provide and save food, and to teach us to fight other than [with] physical weapons."[24] Smith argued a point echoed by many others during World War I (a point again echoed with even more vigor during World War II): that the museum should rethink efforts for the duration of the war. Smith saw practical value in instructing nurses, factory workers, miners, and farmers for the benefit of the greater good, namely, the war effort. He further celebrated what he saw as creative responses to wartime challenges. At the AMNH in New York, for example, an exhibit on Indigenous agriculture and foods

was reframed to suggest to visitors how native plants might be used for food in North America during wartime.[25]

The vivid rhetoric used in embellishing calls for museums to become more pragmatic during the wartime crisis reflects the intense nationalism prevalent in this era. Smith's article continues, "Historical museums are important in war time as in no other period since they can stimulate the true patriotism that is so essential to success." He added, "In such a time collections of war material may be made that would be harder to secure at a later time."[26] Smith was not alone in calling for museums to think of the war as an opening, but his call reads as more nakedly opportunistic than some others.

No museum, in Smith's view, was spared the responsibility of thinking about the war as a time for a dramatic change. "The scientific or research museums, university museums, school museums, children's museums, kindergarten museums, public museums, recreation, tourist or vacation museums, farmers' museums, commercial museums, national museums, and many other kinds of museums all have opportunities to do war work."[27] How medical museums might benefit the war effort was more obviously clear than how "kindergarten museums" might, but for Smith and many others, the general point that all museums needed to reconsider their operations in wartime proved to be a salient rhetorical turn that worked to overshadow many other possible avenues of discourse about museums in the era. Not only was every museum expected to consider its role, but every department within these institutions was also asked to engage

in similar reflections; Smith added, "Every department of a museum can do something to assist in war work."[28] He concluded, "The general knowledge of museum men may be applied to war work and in some instances be of greater service than scores of men."[29] Although the calls for museums to join the war effort were now apparent, it remained unclear how exactly museums would engage in the war work called for by so many leaders.

By 1919, even after the jolt of the influenza pandemic was felt by museums and their administrators, an emphasis on how museums had survived the wartime crisis seemed to draw the most attention. In reviewing US life at home during World War I, the historian David Kennedy argues that a US suspicion of public power and a bias toward volunteerism in social institutions carried over from earlier eras through the war.[30] This wave of volunteerism had certainly hit museums, where staffers volunteered for military service, the Red Cross, and government positions during the war years. Around the corner, however, lay an even deadlier enemy for many museums in North America.

Pandemic, 1918–1919

It was autumn in 1918, and Charles Eastman did not feel well. Eastman, a scientist who specialized in the prehistoric sea life of South America, traveled to the seaside town of Long Beach on the southern coast of Long Island to get out of the city and find some fresh air. He needed a break away from his everyday pressures working at the American Museum of

Natural History on the Upper West Side of Manhattan. Work had gotten more intense recently, mainly as a result of the war, and the pressure was starting to get to him.

Eastman had felt pressure before. In 1901, while working as an instructor at Harvard, he had been accused of shooting his brother-in-law, a shocking charge for which he was later acquitted.[31] Eastman had hoped getting away from the city and taking in some fresh sea air would help him recuperate from what the *New York Times* described as the new pressure he had recently been under. "According to friends," read the newspaper, "he had been suffering from overwork while a member of the War Trade Board in Washington." While walking on a boardwalk near the ocean, Eastman started to feel faint. Days later, the body of what was described as a well-dressed, middle-aged man was found washed up at the end of the boardwalk. The newspaper reported that Eastman was thought to have fallen into the sea after "he suffered an attack of Spanish influenza."[32] As was true with many things surrounding the creeping pandemic and its influence on museum lives, the details and circumstances were unclear. What is clear is that the 1918–1919 influenza pandemic struck museums quietly but with real force, a fact that many were reticent to fully acknowledge in later reports. As was true with Eastman, the strain connected to World War I seemed to overshadow the notable human tragedy caused by the influenza pandemic.[33]

Although many museum leaders, staffers, and visitors did not realize it at the time, a silent enemy was sweeping across much of the planet. Perhaps originating in Kansas, the

virus was carried by US troops overseas to Europe and back again to the United States. The deadly influenza virus killed a shocking number of people, maybe fifty million worldwide. Newspapers in different cities around the country carried daily reports updating readers with the current death toll.

The virus proved aggressive, targeting young people with especially violent effects. People found themselves with a persistent cough, bedridden by the sickness before having their lungs fill with fluid, turning blue, and in many cases dying. Medical professionals and family members, unsurprisingly, found themselves caring for hordes of sick individuals. The Oakland Auditorium, with space for the Oakland Art Gallery, was cleared out to make room for a temporary Red Cross hospital. In some cases, entire cities, including Nashville, Atlanta, and St. Louis, were ordered shut down by government officials. In cities like Philadelphia, large gatherings such as parades were allowed to persist. Flu ripped through Philadelphia to a devastating degree, compelling people at the art school adjacent to the city's museum to report simply, "Early in the season the students had influenza." The art school's dealing with the epidemic, however, was not reported to be as devastating as it may have been. The museum chronicled, "As we look back, it has been a happy winter, our difficulties drawing nearer together and giving us an added respect and affection for each other."[34]

Museum attendance numbers in this period declined, and some sharply dropped, even in cities that were spared a mandated lockdown. The 101,504 people visiting the Smithsonian castle in Washington, DC, in 1918–1919 became just

86,013 in 1919–1920. Attendance to the Arts and Industries building declined too, even as more visitors were starting to walk through the halls of the new National Museum of Natural History.[35] Overall, however, the numbers were trending downward basically everywhere.

When adding up all "numbers reached" totals by tabulating visitors to exhibitions, lectures to school children, and people touched by circulating exhibitions, the AMNH in New York City similarly experienced a decline in total attendance. In 1917, the museum estimated that it had reached just over 2 million individuals. In 1918, this number dropped to about 1.5 million people, before rebounding some to 1.8 million in 1919.[36] Probably contributing to vacillating attendance levels were a spate of riots emerging from the many ugly racial tensions also defining this era. White supremacists in New York, Chicago, and elsewhere across the country engaged in terroristic violence against Black Americans, including uniformed service members. The murders and violence, which were especially virulent during summer 1919, became known as "Red Summer" and no doubt contributed to an overall climate of tension and unrest that reduced possibilities for public life.

Despite the obvious hit to attendance figures published by leading museums, many were content to mostly look the other way. Race riots and violent strikes were modestly described as "unrest." Bad weather was another convenient excuse. Many lengthy museum reports from the era do not even mention influenza, suggesting that museum leaders

were hesitant to grapple with the public health problem directly, perhaps thinking it might keep away visitors permanently or being themselves unable to fully comprehend it as a problem.

The pandemic's devastating human effect peeks through in curious ways throughout museum reports. In a tragic episode relayed by the New-York Historical Society, an American Indian collaborator, a Seneca man named Jesse Cornplanter, or Sosondowa, returned home from France, where he served during World War I, only to learn of devastating personal losses. His family had long been a prominent source of Seneca knowledge, some of it shared with curious researchers hoping to capture it for the museum. Arriving back in New York following the war, Jesse returned home to find that his father had recently died; his wife soon passed away as a result of influenza; then most of his children perished. The museum reported of its young collaborator, "Of the large Cornplanter family that Corporal Jesse Cornplanter left, only one sister will greet his return, and there will be two destitute children of a dead sister to care for. This is a tragedy in peaceful America that a returning Seneca warrior must face."[37]

Indeed, the pandemic was striking museums in notable ways, bludgeoning the people connected to them with illness and resulting in declining attendance figures. With the war having ended and flu season thought to be coming to its natural end, many museum leaders were keen to look away from the recent setback and turn their sights back onto future endeavors.

Recovery, 1919–1923

The rapid nature of the museum recovery from the flu pandemic was probably due to several factors. The pandemic had caught many people by surprise, a crisis event partway complete by the time people even came to recognize it.

Boston's Museum of Arts reported, "People are deterred by . . . bad weather,—rainy Sundays, and there have been many this year, reducing the attendance far below normal."[38] There were many other distractions in the era. Previously, temporary fairs and international expositions had captured the popular imagination, as hordes of curious visitors would rush to the temporary exhibitions. But the Bronx International Exposition of Science, Arts and Industries, held in 1918, had even been a flop. The fair failed to capture popular imagination in growing worry's midst. During 1918 and through much of 1919, the US economy faltered, worsening the situation. A mild recovery began in 1919, before a sharp decline hit in 1920. By 1923, however, the US economy was recovering, starting the boom characterizing the 1920s. Museums would eventually benefit from this widespread economic prosperity.

As the pandemic began to wane, museums were already starting to look back and assess struggles in their recent history. For instance, the graduation scheduled for students at Philadelphia's School of Industrial Art had been postponed several weeks, "to compensate for the loss of time caused by the closing of the School for three weeks in October on ac-

count of the epidemic of influenza."[39] The end of the war, the brief economic recession, and many other factors all seemed to cloud the exact nature of the changes happening at museums and in broader US society.

In spite of the many distractions, the flu and pandemics were still, in some cases, on people's minds, and museums planned to address the subject in programming. Masks became more common as a public health measure by 1919, and while it is likely that such face coverings were worn in museum spaces, photographs of masked visitors are rare. By 1920, the AMNH described plans to alter its planned *Natural History of Man* exhibits to include a section "dealing with the transmission and control of the contact-borne diseases, such as influenza."[40] As was true with many things connected to the historical memory related to influenza, much of the commitment to popularizing public health education programs in this way dissipated by the Great Depression.

The brief but noticeable removal and subsequent recall of many staffers, adjacent students, and family members also attracted attention. It seemed to be a busy time for museums in general. The art museum in Philadelphia was led by three new directors in just one year, its most recent called away by the Smithsonian to collect art in Japan and China.[41] An absence of stable leadership, or a rotating door to leadership offices, often makes planning for the future difficult, if not impossible. Problems are sometimes ignored or allowed to slip through the cracks. When filling a recently vacated leadership seat, new museum directors often felt compelled to

think big, further distracting from seemingly smaller "on the ground" concerns facing institutions. Between 1919 and 1920, new museum buildings opened in San Francisco, Cleveland, and Chicago. Construction had also begun on a grand new art museum building in Philadelphia. In 1923, the same year an economic recovery began in full swing, the American Association of Museums (now the American Alliance of Museums) opened a new office in the Smithsonian castle. The future, for museums at least, seemed bright.

Despite the calamity's significance, museums are reflective of the idea that the 1918 flu represents "the forgotten pandemic" in twentieth-century history. The war and many other important events seemed to overshadow the influenza's apparent significance. Many individuals writing and thinking about museums barely seemed to notice the pandemic's effect on museums, as the outbreak was so shrouded by other consequential events.

Museums of all kinds were asked to retool and reimagine their role in society for the war effort. Even before the war, however, writers and museum leaders like John Cotton Dana were calling for institutions to become more practical and modern. A museum should be, in his words, "of definite use to its community."[42] Writers like Dana had started forging a different path forward for cultural institutions in the United States, but confusing twists lay just ahead. US involvement in World War I ended relatively quickly, but the pandemic that quietly grew right as the war ended was poised to leave a lasting mark. Economic uncertainty was also clearly a factor. The whiplash experienced by the US economy overall hit the

pocketbook of workers who might otherwise have spent the day at the museum. As visitor numbers dwindled, so too had the rate of new museums opening for a time.[43]

Whether underreported at the time or not, the story of museums and the deadly influenza outbreak was further pushed aside by the success that many museums went on to experience in the 1920s. Remarkably, annual reports from 1920 and beyond frequently make little or no mention of the pandemic that was experienced so intensely by many major US cities in 1918–1919. Beneath the surface, however, were serious implications for museums and the people connected to them. Plans had been changed and lives altered.

Museum reports rarely correlated the clear increase in attendance numbers with the decline in influenza cases, but it was likely that the improving public health situation contributed to a postwar bounce. In Boston, where overall attendance was starting to improve, the art museum fielded 4,877 requests for guided tours in 1919 and 5,989 in 1920.[44] Similar figures ballooned through the 1920s as museums grew in their overall prominence. Although they would be increasingly competing with the radio and other forms of popular media for attention in the later 1920s, urban areas were steadily growing, and museums expanded alongside the booming cities.

During the war and influenza pandemic, however, museums had curtailed plans for collecting expeditions, visitors to museums had declined in number, and people who were intimately connected to museums had suffered from illness and death. Regardless, with grand new buildings, important ac-

quisitions, and staffers returning home, the many challenges faced by museums in the United States between 1914 and 1920 were largely forgotten. The changes and challenges appeared temporary and unusual rather than an event, or series of compounding events, that might be similarly encountered by museums again at some later date. While US museums became somewhat more engaged with global events during the war and pandemic years, the sudden temporary changes resulted in minimal lasting effect. Perhaps because of this, the era is thought about less by historians of cultural institutions. Although a more fulsome consideration of what had been experienced by museums in the United States between 1918 and 1920 would have proven beneficial, the era is mostly overlooked in museum history.

On May 2, 1921, massive crowds lined up to enter the sparkling new Georgian white-marble building constructed for Chicago's Field Museum of Natural History. Fears about contagions and war already seemed to have faded. Museums and their visitors believed that they were looking into the glistening new exhibit halls and ahead into a brighter future.

The Hearst Museum of Anthropology and the Great Depression

The Great Depression was in many respects unparalleled in the challenges it presented for museums and other cultural institutions. Museum reports note the economic reality soon after the crash, and the optimistic outlook typically presented in those pages became notably darker and more realistic as the depression wore on. Staffers were let go, exhibitions canceled, and expansion plans downgraded. The ambitious growth that museums experienced in the late nineteenth century had slowed during the years around World War I and the 1918 influenza pandemic. Now, with the Great Depression setting in, museums were once again unable to mount as many major expeditions; few funds remained for purchasing collections, and public programs were canceled.

As the US economy crumbled after 1929, museums faced dual crises. Not only were public institutions struggling financially, but academic disciplines like anthropology had started to shift their focus away from material culture studies toward more theoretical, often university-based research. Historians have long cast museums as struggling through the Great Depression, slogging through challenging economic times and intellectual shifts in academic disciplines toward

World War II, but this version of the story, it turns out, was overly simplistic.

Indeed, economic collapse frustrated efforts by museums to send collecting expeditions across the globe. Compounding these problems, rapidly growing research universities were luring top curators to academic posts: Franz Boas left the American Museum of Natural History to teach full-time at Columbia University. A string of his students including Alfred Kroeber and Ruth Benedict went on to advance US anthropology theoretically as well as in its overall reach globally.[1] Funds seemed to be drying up for many museums. Major philanthropists had already started shifting some emphasis to hospitals and universities in supporting medical research and the other sciences. By the time of the depression, exhibits that seemed fresh and new in the early twentieth century now seemed outdated. The crash caught the city of Philadelphia in the midst of a museum expansion. The city's budget was so decimated by the catastrophic economic context, however, that construction on a new wing for the Philadelphia Art Museum was temporarily halted as appropriations dried up.

It is understandable, then, that the historian and anthropologist George W. Stocking describes this era as the "dark ages" for the museum in the United States. About museum-based anthropology, in particular, he writes, "by the outbreak of the second World War . . . museum anthropology [was] stranded in an institutional, methodological, and theoretical backwater."[2]

By the early 1930s, the University Museum at the University of California, now the Phoebe A. Hearst Museum of

Anthropology, had already faced numerous challenges. Not only was it seen by many people as being a distant outpost for a new science (becoming the largest anthropology museum on the West Coast), but it had already weathered the earthquake and fires that devastated San Francisco in 1906. The Great Depression, however, presented unrelenting difficulty for museums by cutting off funding that was available even a few years earlier. Cash given to museums from donors dried up, and objects formerly offered to museums as gifts were now offered for sale. At points, it became unclear whether the anthropology museum at the University of California would even survive.

While museums did indeed face numerous challenges during the Great Depression, the response to the depression's trials also influenced many aspects of museum practice. This included new and expanded approaches to collecting, exhibitions strategy, collections management, cataloging, research, conservation, and community outreach. In particular, the on-the-ground implementation of several significant New Deal work-relief agencies injected new life into museums in the United States, especially within departments of anthropology where previous generations of collecting left materials uncataloged, uncared for, and largely forgotten.

New Deal labor supplied a partial solution to the many problems at hand. The workers contributed millions of person-hours previously unavailable to even the larger and better-funded museums in the United States. Most workers were hired through the Works Progress Administration (WPA) or the National Youth Administration (NYA). Lost

within the person-hour statistics and the number of work-relief laborers arriving at the museum is the fact that the New Deal reignited significant cultural production created in museums. Namely, New Deal laborers were not merely rebuilding exhibitions; they also made significant contributions to museum research. The funding stimulus and support quietly shaped cultural institutions for decades.

The argument in this chapter is perhaps somewhat counterintuitive. The Great Depression's constraints in some respects helped museums prepare for a surge in activity set to take place in the postwar era. A major reason for these advances was the help of temporary New Deal workers, who organized museum catalogs and cared for collections at the Hearst Museum as well as numerous other museums around the country. This is not to somehow say that the depression was good for museums; the devastating effects of curtailed programs and reduced staffing represented clear setbacks. Within the challenges, however, were also credible opportunities to advance the respective missions of cultural institutions. New Deal agencies loom large and mostly overlooked in this narrative. Simply stated, the role of New Deal labor in preserving collective US cultural heritage is substantial and merits a larger place in museum history.

In more recent years, the difficult and fraught colonial history of collecting sacred material and human remains for museums like those at the University of California has belatedly been recognized as an intense point of hurt for many California Indian communities. Often, these materials were collected with little or no regard for the wishes of the com-

munities from which they originated. The museum built up a massive collection of California Indian human remains as it also gathered baskets, clothing, and thousands of other objects, all classified and arranged in what was thought to be a scientific approach. This process gradually continued even during the tumultuous events of the 1930s.

This chapter asks how museums might survive and adapt to new conditions during lengthy economic downturns like the Great Depression. In particular, I ask how the Hearst Museum of Anthropology at the University of California withered in response to some challenges, while successfully reorganizing, rebuilding, and reimagining the museum for an era to follow in response to other demands. How did this and other museums respond to the many problems at hand in the Depression era?

The Hearst Museum

Phoebe Apperson Hearst (1842–1919) funded and helped to organize the creation of a new anthropology museum at the University of California in 1901. Hearst financially supported the entire department and museum for the first seven years of its existence.[3] Her philanthropy to the University of California reflected a desire to jump-start research in newly expanding scientific disciplines at the university. Hearst made a conscious decision to focus the department's efforts on research rather than teaching or popular exhibitions.[4] Her ideas and dedication to the university in this way fit well against both the ambitions held for the state of California

and its emerging institutions, but also the widespread ideas about museums as research centers in this era. Operating on the Parnassus Campus in San Francisco, the museum drew a relatively sizable number of visitors. The institution is today situated on the Berkeley campus and named the Phoebe A. Hearst Museum of Anthropology in recognition of Hearst's early philanthropic and intellectual contributions to the museum, which was called the University Museum during this era.

Among the most important decisions made during this early era was to hire a young anthropologist from New York named Alfred Kroeber. Kroeber, a student of the anthropologist Franz Boas at Columbia University, would emerge as one of the leading scholars of California Indian life and society in the twentieth century. Initially brought out to California to work at the Academy of Sciences in San Francisco, he was soon teaching at the university and serving as a curator at the school's new museum.[5] By this time, Kroeber's mentor, Boas, was established as one of the luminaries in US anthropology. Boas, in addition to Frederic Ward Putnam, the director of the Peabody Museum at Harvard University, advised Hearst, and the University of California, in establishing a new museum. Together, they would shape much of the early trajectory for the department and museum, but it was Kroeber, on the ground in the Bay Area, who assumed many of the day-to-day responsibilities involved in starting and running a museum.

In addition to Kroeber's training at Columbia, he had studied the collections at the AMNH and was encouraged to

use the museum as a sort of research lab in his early studies. He no doubt had this experience in mind when he moved west to shape museums in California.

The new department and museum first moved to establish itself in the mold of older East Coast institutions, yet it recognized its unique position to obtain significant California Indian collections. While the museum indeed embraced its global focus, bringing to California ancient archaeological material from Peru and Egypt, many of the early collections brought to the museum were spectacular examples of California Indian material culture. The museum also began collecting hundreds of human remains, including the dozens of accidental discoveries and the intentional uncovering of gravesites taking place during early archaeological expeditions throughout the state.

In the museum's first twenty years, it hosted 334,567 visitors.[6] While modest on a national scale, annual turnstile numbers represented a respectable figure for a budding California museum in this era. The institution featured a modest exhibit space that, already by 1920, could only display half of the museum's growing collections.[7]

Other museums, too, were competing with the new museum at the University of California for cultural objects. Although the Hearst Museum came to represent one of the largest anthropology collections west of Chicago, it was among a number of key institutions established to collect and research anthropological material by the early twentieth century.

As described at the end of chapter 1, museums were largely looking to the future by the 1920s. Bold new museum ex-

pansions were taking place across the country. As previously noted, the Field Museum of Natural History in Chicago opened a larger museum building in 1921. The University Museum at the University of Pennsylvania opened a new wing in 1929. As mentioned earlier, some of this construction was halted in places during the early years of the Great Depression. But by 1936, the American Museum of Natural History in New York opened a sparkling new rotunda to welcome visitors. The leadership at Berkeley's Hearst Museum, meanwhile, hoped private donors would step in to help provide funds for a new museum building.

The Great Crash

Almost immediately after the economic meltdown of 1929, many museum leaders shifted their rhetoric to emphasize fiscal responsibility. The Peabody Museum at Harvard reported, "In spite of these difficult times, the Museum has been fortunate in its progress. With the practice of the strictest economy, seven expeditions have been put in the field . . . and the task of reorganizing its collections has gone steadily forward."[8] The rhetoric of financial responsibility would grow louder during the course of the depression, and this made justifying new expenditures challenging. Both public and private institutions hoped to make a case in their annual reports that every measure was being taken to curtail expenses and emphasizing that philanthropic efforts would go an especially long way during challenging economic times.

As a result of the prevailing ideas about employment in this era, women were among the hardest hit by the catastrophe. Women were terminated from many museum jobs almost immediately. Women had worked at the Hearst Museum, largely in clerical and cataloging positions, since its early origins. The number of women in workplaces overall had grown early in the twentieth century, and museums were no different in this regard. Now, however, with the perception being that men were earning the necessary money to provide for a family, women workers at both the Hearst Museum and more generally were first to be deemed nonessential and let go. This gender discrimination was a harsh reality of the time, and it is unclear how much these savings helped the museum bridge the financial collapse in the short term. The organizational loss was clearly apparent, however, and the loss of regular income was no doubt felt by those who were let go by museums during this era. Gender discrimination in hiring and wages remains a problem in the museum industry.[9]

Early in the Great Depression, Hearst Museum programs aimed at public outreach were shelved. A lecture program for elementary and middle-grade students was abandoned due to a lack of funds and space to host the young visitors.[10]

Uncertainty at the University Museum

In 1931, with the economic crisis worsening, the Hearst Museum was forced to pack up and move across the bay to Berkeley. University leaders had made the decision to close

several buildings in San Francisco, including the museum, and move the material to join the main campus. Remarkably, very few objects in the collections were damaged or destroyed in the move. Having packed up and transported thousands of priceless objects with minimal incident, the museum largely packed away its collections again and stored them into various corners across campus. Much of the museum's collection was moved into the university's Civil Engineering Building, with only two modest rooms designated for occasional exhibitions.[11]

Kroeber was not only fighting for space to display and maintain the collection; he was fighting for the museum's life as an autonomous institution. When he caught word that the university administration was considering combining the school's art and anthropology museums, he wrote a memo directly to the school's leadership pleading his case that "anthropology is partly a natural science and partly a social science, and that therefore too close an affiliation with art would be misrepresentative and prejudicial."[12]

Some scholars would later describe Kroeber's quest for a new facility as a story "of heartbreak and delay."[13] The museum found itself with a crushing lack of space for collections, virtually no room for exhibitions, and no real plan for the future. Devastatingly, an anticipated donation from the Hearst family, intended to be used to build a new museum, was canceled. A new facility for the museum would not be completed until 1960.[14] Kroeber, however disappointed he might have been that his proposals for a new building were consistently being turned down, maintained that research,

not exhibition, was the most significant role for the museum. Exhibition was a desirable aspect of a university museum, but it was clearly considered a secondary need as compared to collections study and research.

Losing collection display space did not quell Kroeber's desires to coordinate fresh exhibits. The exhibitions in the new space were changed annually or on a semester-by-semester basis depending on the available budget. Temporary exhibitions highlighted selected collections in display cases before rotating out new material. With regard to exhibitions, this led to an important development, the museum became notably more agile in responding to the new circumstances.

During the interwar era, the University Museum worked to develop a collections strategy to address the haphazard methods of collecting that had been adopted in the museum's early history. Although the museum had gathered collections from all over the world early on, an important California Indian survey organized by Kroeber and his colleagues brought to bear significant material culture collections from around the state.

In the second half of the nineteenth century and into the twentieth century, people connected to museums in the United States became concerned with cultural salvage, often termed by historians to be "salvage anthropology." Salvage anthropology was the response to the widely held "vanishing Indian" myth that held that Native people were doomed to disappear at the hands of modernity's constant onslaught.[15] Kroeber's vision for a museum grew to include all kinds of materials documenting purportedly threatened people.

This included thousands of objects and human skeletons as well as key documents and audio recordings. As the collection grew, the museum became an important center for the evolving cultural salvage movement, with the hope that cultures thought to be more "traditional" in orientation could be rapidly documented, collected, and gathered before they were permanently altered by modernity. Kroeber emphasized collecting that was centered on intensive stays in the field. He preferred to collect objects that had been used in what he considered a traditional fashion and would generally only collect newer objects as reproductions or models.

It might be assumed that the museum's lack of funds for purchasing collections and severe budgetary restrictions in mounting museum-run collecting expeditions led to a total halt in acquiring collections; this did not prove to be the case. Although the museum was unable to acquire every object on its wish list, it did embark on a series of low-cost and creative endeavors that helped the collection both grow and become more focused. Problems relating to constrained economic conditions were not unique to the Hearst Museum, yet they have been understudied overall in the available museum literature.

In 1931, even as the museum made its move across the San Francisco Bay, it exchanged material with other institutions including the Peabody Museum at Harvard, the AMNH, and the University of Utah.[16] The exchanges were not limited to other museums. In 1939, the museum anthropologist Edward Gifford collaborated with a California automobile dealer who discovered human skeletal material and "other artifacts" on

his ranch. Once Gifford learned that the man held more than a passing interest in archaeology, he negotiated an exchange for the material by offering books and other publications as trade fodder.[17]

Kroeber would himself set some of the standards for collecting, seeking representative materials either in use or considered "old fashioned" by tribes in Northern California, documenting each object and its use in situ. Kroeber worked with graduate students interested in ethnography and archaeology, encouraging students like Robert Heizer and Isabel Kelly to conduct archaeological surveys across Nevada, California, and into Mexico. The work initially included short project and weekend trips but by 1948 grew into the larger and more formal University of California Archaeological Survey.[18] Kelly was encouraged by Kroeber to pursue archaeological fieldwork in the Southwest, in part to add to the museum's collection in ways he desired, before pursuing work in Sinaloa, Mexico. She was later awarded Guggenheim Fellowships and collaborated with both the government of Mexico and the Smithsonian Institution on archaeological work during World War II and after.

Most often, when graduate students returned from the field, after collections were organized, cataloged, and "written up" into scientific reports or dissertations, the material was stored away with the rest of the collection, sometimes swapped or traded away to fill in other perceived gaps. Through the work of Kroeber and his graduate students, the museum was thought to have assembled the largest archaeological collections from the west coast of North America, "on

assembly anywhere," which "will be basic in all future intensive studies."[19]

Museums in this era received a near constant stream of letters offering objects of varying significance for purchase. Even before the depression's onslaught, museums like the University Museum at the University of California were rarely in a position to buy such objects. Kroeber once replied to an offer by describing the museum as "interested but impoverished."[20] He responded to another offer by explaining that most public museums were "doing practically no buying," but if the inquirer were feeling "philanthropically inclined," the museum would gladly accept a donation.[21]

Buying objects, though rare, was not entirely out of the question. The museum's limited purchases, however, usually reflected opportunities to acquire material that was measured as professionally collected, following a presumed level of rigor and documentation considered to be associated with archaeology and ethnography as a museum-oriented discipline in the early twentieth century. In one example taking place in 1931, University of California president Robert Gordon Sproul solicited five donors to contribute $100 each to buy a desired collection.[22]

A new infusion of labor was about to provide the museum with a boost. Temporary new staff could help behind the scenes and refurbish public-facing exhibition spaces.

Museums and the New Deal

New Deal programs greatly affected museums in the United States. The New Deal was a series of government initiatives responding to the Great Depression, including an array of government works programs seeking out projects of all kinds while putting to work unemployed or underemployed laborers. It created new opportunities for museums in what was proving to be a chaotic time.

Museums embraced several work-relief agencies, including the Civil Works Administration (CWA), Works Progress Administration (WPA), and the National Youth Administration (NYA). More specifically, laborers from relief agencies were put to work on two major tasks: building or repairing exhibition spaces and organizing existing collections. A centerpiece of the relationship between museums and the New Deal was the WPA's Museum Extension Project (MEP). The MEP crafted new artworks, dioramas, and exhibitions for museums across the country. The program worked with a wide range of museums, from smaller local history museums to major natural history and art museums. Notably, the MEP employed artists and other craftspeople to construct museum dioramas depicting a range of subjects, from the Cliff Dwellings at Mesa Verde to the events of the French Revolution. Many museums considered the dioramas to be an inexpensive and popular method for refurbishing portions of outdated exhibitions.[23] Although the small MEP dioramas provided a relatively quick and inexpensive fix to outdated exhibitions, the most important aspect of the New Deal for

museums in the United States was the availability of labor for larger projects.

The Metropolitan Museum of Art in New York acknowledged the contribution of its New Deal programs, noting, "The museum is indebted to the Works Projects Administration for the substantial contribution of WPA employees to the work of almost all departments."[24] The Hearst Museum utilized NYA and WPA assistants in numerous ways between 1936 and 1942. This included direct support for research projects, in laboratory spaces, and in basic clerical work. In completing an extensive classification of California shell artifacts in the museum, Gifford utilized a steady flow of teenaged NYA assistants, later publishing several journal articles on the resulting work.[25] For a time, New Deal workers seemed to be everywhere in the small museum.

The most important WPA project at the Hearst Museum, however, began in 1939. During a two-year project, the museum enlisted WPA workers to complete a detailed card copy based on the museum's yellowing catalog records. The annual report for 1939 outlined the project's goal: "This will permit a grouping of the specimen records by locality and type, instead of merely regional and inventory number."[26] The card catalog was a valuable addition to the museum's resources for researchers. Classifications and arrangements of objects that contemporary museum professionals largely take for granted were not possible with older ledger-book catalogs. Older catalogs grouped objects by region and then by accession group of individual catalog number. The new catalog card system allowed researchers to explore classification that was

made possible in the past "only by physical segregation of objects, which limitations of space frequently interfere with."[27] Despite lacking sufficient storage space for new and existing collections, the museum nevertheless fielded more general inquiries from the public than ever before.[28]

Within a few years, the new card catalog allowed researchers to complete their work with more rapidity and permitted them the chance to increase the complexity and variety of their studies. In 1939, the museum's annual report indicated that nine research projects of various sizes, based on museum collections, were taking place.[29] By 1943, the museum reported a dozen projects; in 1945, that number had increased to fourteen.[30] This was all taking place *before* the massive infusions of cash and labor following the war thanks to programs like the Servicemen's Readjustment Act of 1944 (better known as the GI Bill), which injected new life into many university museums.[31]

Despite numerous budget constraints and limited storage space, Kroeber believed that the work of staff and graduate students could fruitfully turn inward, focusing on organizing and maintaining the valuable collection. By 1933, he announced, "The Museum is now one of the most completely inventoried and intensively classified in the country."[32] Kroeber and Gifford were keenly aware of the perceived strengths and weaknesses of the collection and were willing to make accommodations to add to the material.

The Hearst Museum's use of New Deal–era programs was far from unique. The Field Museum in Chicago offers an interesting comparison. During the 1920s, the Field had funds

to employ only *one* noncuratorial staff member. Between 1930 and 1939, the Field's Department of Anthropology enlisted a total of forty-four noncuratorial staff members. When the New Deal ended, the department's staff was again reduced, having only fourteen noncuratorial staff in the 1940s. The Field Museum did not reach New Deal levels of anthropology staff again until the 1990s. In Chicago, as in Berkeley, New Deal staffers helped catalog new accessions and organize information for curatorial publications.[33]

The Smithsonian Institution, too, took advantage of New Deal work-relief agencies. While early incarnations of work-relief agencies contributed labor to the Smithsonian in the early New Deal years, the arrival of WPA laborers in 1936 provided a more systematic labor infusion. The WPA program at the Smithsonian would eventually grow so large as to require its own central office, where staff oversaw timesheets and recorded the projects of laborers. In addition to major cataloging work, the Smithsonian utilized New Deal labor to organize library materials, mount specimens, and translate foreign documents.[34] At its peak in 1938, the national museum housed 167 workers, but it lost its WPA assistance in 1940 due to budget shortfalls.[35] The program was eliminated entirely soon thereafter.

When it became clear that funds for the WPA at the Smithsonian were running low, curators in anthropology begged for their continuation. One appeal is in a letter written by curator H. W. Krieger (typed up, no less, by a WPA stenographer). He stated, "An incoming W.P.A. worker feels lost. He or she had no professional training in ethnology but has been

selected for special intelligence and a more or less developed mastery of technique along the line of the proposed assignment of duties." Once a worker had been trained, Krieger argued, they became a major asset to the department. Just as they were catching up with cataloging backlog, new collections were pouring into the Smithsonian, waiting to be classified and arranged on museum shelves in such a manner that would provide for its future discovery in a predictable location and relatively stable condition. WPA workers at the Smithsonian, Krieger argued, were making new forms of research possible as well as helping to preserve information and collections for future generations. Krieger appealed, "The work of the individual W.P.A. workers . . . has a permanent value in that records of collections are being made in a permanent form and the preservation of specimens has become a major object of effort."[36] Despite the appeals made by Smithsonian curators, the program was terminated.

During the program's four-year run, the Smithsonian received 248,196 person-hours from New Deal laborers working at the museum. New Deal laborers participating in the program, for their own part, were thrown the lifeline of stable employment in an otherwise miserable economic climate. Given what we know about the time, many were probably happy to have any job.

In addition to internal museum work, New Deal agencies also contributed to new archaeological surveys taking place around the country. Many of these programs were coordinated by the Smithsonian. Laborers from the CWA, WPA, and the Civilian Conservation Corps (CCC) contributed to

archaeological projects in twenty-four states over the course of nine years. These surveys resulted in new collections for the Smithsonian as well as other museums around the country. For example, a Smithsonian survey supervised by the archaeologist William Duncan Strong in California's San Joaquin Valley, starting in 1933, was staffed mainly by CWA laborers and resulted in the collection of 1,607 archaeological objects given to the Hearst Museum.[37]

The effect of New Deal agencies on museums in the United States is difficult to overstate, yet dependence on such programs in museums throughout the country was not entirely universal. The programs did produce a supplemental workforce that was largely efficient and productive, but the lack of long-term stability prevented the program from having an even larger impact. The WPA contributed the largest number of temporary workers to museums in the United States and was not even formed until 1935, six years into the prolonged economic calamity. Although the bulk of archival material about the New Deal in museums praises the work of laborers, sporadic complaints appear about worker laziness and the amount of time needed to train new staffers.[38]

New Deal works programs had quietly injected new life into museums largely working behind the scenes. More visibly, however, they rebuilt many aging exhibition spaces in museums across the country and assisted with the reorganization of museum collections, making possible future research in these same institutions. While many museums across the country benefited from the full array of New Deal programs as they related to museums, the University of Cali-

fornia mostly applied works program initiatives to behind-the-scenes work.

Things started to pick up for the Hearst Museum at the University of California, Berkeley, around World War II. Despite wartime restrictions and numerous other limitations, the museum was starting to make new strides. Between 1939 and 1945, the museum increased the total number of cataloged objects in its collection from 153,297 to 168,196. This was due in part to a continued effort to catalog existing collections, building on the work accomplished during the Great Depression. During the same period, the museum averaged over thirty-two hundred visitors a year.[39] School programs returned to the museum, and visits from upper and lower grades added to the university students visiting temporary exhibitions, now rotating on a two-week basis.[40] Attendance steadily grew during the war years as the San Francisco Bay area experienced an economic boom.[41] As was true with many things in US life, after a brief slowdown in 1946–1947, the postwar boom seemed to continue. Between 1947 and 1948, the number of graduate student researchers using the Hearst Museum's collections doubled.[42]

One might reasonably hold that, considered from one point of view, the depression was utterly devastating to the Hearst Museum: it went from having a permanent museum building and a significant and growing stature in an emerging new science to having very little at all. In just a few years, the museum no longer had its own permanent space, and programming was handicapped or eliminated. In other aspects of museum operation, however, such as organizing the

collection and creating future resources for researchers and educators, the museum made significant strides in this challenging time.

A closer look at the history of the Hearst Museum allows a better understanding as to why previous scholars of US museum history have mostly overlooked the period between the Great Depression and World War II. In surprisingly significant ways, however, the Hearst Museum underwent important transitions helping lead to the explosion in productivity and renewed interest after World War II. The significance of the injection of New Deal labor to supplement existing museum staff, in particular, has largely been forgotten. Further, the manner in which New Deal laborers contributed to museum-based heritage preservation and the production of knowledge has largely been omitted in US cultural history.

Whereas scholars have often depicted museums of the Great Depression era as being merely on life support, revisiting their history suggests instead that museums like the Hearst Museum not only maintained their pulse through challenging times but also continued to offer new scholarship and gather collections during the hardship. They created exhibitions that provided diverse (though not entirely inclusive) audiences with an outlet. A largely inward focus, however, helped set the stage for a reimagined museum to become even more productive after the war.

The history of how museums responded to the challenges of the Great Depression suggests that they can only rightly be classified as an intellectual and institutional backwater (to rehash just once more the framing of the historian George

Stocking), if you take the narrowest, academically focused, view on the matter possible. When looking beyond curatorial staff and the publications they authored alone, museums advanced a great deal with regard to collections management, exhibition design and upkeep, and facilities management—all crucial aspects of museum operation that some historians have missed in their assessments.

In 1945, Kroeber penned an eight-page retrospective about his career. He noted that while the growth of new collections at the University Museum slowed after the rapid initial progress taking place under the early guidance of Phoebe Hearst, the rate of growth of the collections between 1936 and 1946 had actually outpaced the overall rate of growth in the course of the museum's history.[43] While the development of collections is far from being the only indicator of the health of the museum (far from it), Kroeber nevertheless believed that the evidence indicated that museums were not as clearly declining as some people might be led to believe. He lamented, however, that the vast majority of the remarkable collections that the museum had amassed were tucked away in storage, away from where most people might see them or even know of their existence. He wrote about the museum he cared for so deeply, "Its collections are probably the only ones of their quality and size in the country kept wholly in storage on account of a lack of facilities to exhibit any of them."[44] Kroeber remained connected to the museum up to his death in 1960, the same year a small building was finally opened on campus with space to exhibit some of the museum's remarkable treasures.[45]

Early in 2021, the University of California, Berkeley, announced, in response to an important study and the activism of key voices (especially Native voices) in the campus community, that Kroeber's name would be removed from the building housing the Hearst Museum of Anthropology. The removal of his name from the building recognizes an evolution in thinking about his fraught place in the story of museums, anthropology, and the exploitation of Native people in the process of collection building during the nineteenth and twentieth centuries. Always outweighed by his ability to right the museum's administrative ship during difficult times, Kroeber had crossed important ethical boundaries in the almost limitless quest to gather and preserve. A longer view suggests an important truth about museum crisis: problems are always refracted through the lens of perspective. Hinged on the plans of even the most driven museum leaders, cultural institutions were limited not just by the crisis of the moment but by the problems inherent to their very existence.

The Smithsonian and Museums during the World War II Era

Early in World War II, a remarkable scene unfolded in Washington, DC. Amid the first of several meetings, United States Army and Navy representatives traveled to the nearby Smithsonian Institution. Behind the scenes, museum staffers walked alongside government officials, leading them through exhibition halls to storerooms crammed with artifacts. During this confidential initial meeting, military officers asked to view items originally constructed for seafaring in extreme arctic climates. Museum workers would have gently removed protective coverings from the fragile boats, waiting patiently while government officials examined them in detail, hoping to gather intelligence for modern vessels built for an increasingly mechanized Allied war effort. The boats they unveiled for the Army and Navy were *umiaks*, made by Inuit people living along coastal regions across the North American arctic. The collective assumption was that these boats, used successfully in extreme climates for centuries, might contain ancient secrets that could be combined with modern technologies to be applied to the continuing war effort.[1] Examining Inuit boats was only the beginning. During World War II,

museum collections contributed to knowledge construction in an unprecedented manner.[2]

Museums found themselves mobilized as agents for making total war.[3] The nation's largest museum, the Smithsonian Institution, redirected substantial efforts, assisting the Army and Navy by offering answers to hundreds of practical questions about natural history and culture while remaining open to the public.[4] The Smithsonian's vast material archive was about to take a temporary wartime turn, distinct in many respects from both earlier efforts and the experiences encountered by other cultural institutions during the same period. Other museums would support the war effort rhetorically, but the Smithsonian's range and depth of efforts both direct and indirect was unique and consequential.

Responding to the wartime knowledge crisis, staff from war agencies began to visit the Smithsonian with several aims: they borrowed a rare Inuit parka, for example, to subject it to heat-loss experiments. Military agencies also wanted to see German radio equipment in the collection, as well as poisonous fish and dangerous snakes. They also inspected rare photographs illustrating regional topography, images originally created by museum scientists for their research. Artifacts and other resources that were less recognizably relevant to modern war also came under scrutiny: medieval helmets, wood samples, and lists of meteorological stations around the planet. War agencies suddenly developed a thirst for global knowledge to be quenched only by exploring collections at the Smithsonian and relying on curators' expertise. In the crisis context of war, knowledge that was

previously considered mostly academic was now suddenly deemed more pragmatic to the state than ever before.

When considering World War II's global influence on cultural institutions, historians typically—and with good reason—think first of museums in Europe.[5] These institutions faced devastating bombardment and looting, both systematic and random, and their attempts to recover material lost during the war continue to this day.[6] It took decades for European museums to rebuild.[7] Despite geographic remoteness from the fighting, the war also affected museums in North America.[8]

The war pushed public museums in new directions: secret meetings were organized with military officials, amended publications put forward, and museum spaces transformed. Fresh World War I memories, coupled with the destruction thought possible by modern warfare, moved some museum leaders to accept belief in "the importance of art and cultural production to the process of democracies."[9] Even as museum leaders and other thinkers came to debate the evolving place of the museum in society, few were fully aware of the wide range of services the Smithsonian offered directly to the military during the conflict.

In the run-up to World War II, much of larger rhetoric surrounding museums was already undergoing a shift. Museum leaders were emphasizing some aspects of operations over others. While research was still considered a critical museum function, cultural institutions were thinking more about outreach and education. Museum curators and directors offered visions for museums as contributing to healthy

democracies or improved civic societies around the globe. Although museum leaders of the era deemed appropriating museum objects for making modern global warfare important, they never critically grappled with the implication of doing so: they simply did not (at least publicly) address the moral implications of transforming the museum into a war-making tool.

Museums in December 1941

The Great Depression presented clear challenges to museums in the 1930s. The New Deal provided an infusion of labor in response, yet obvious problems still remained. Namely, significant reductions in museum budgets for new acquisitions, exhibitions, and travel were in place, but in December 1941, museums were also struggling to redefine their role in society more generally.

Most Smithsonian galleries remained open during the war, and both off-duty soldiers and civilians visited the museum. The Smithsonian even printed special postcards for soldiers to send back home to places like Iowa and Texas. Not all museums remained open, however. A prewar guidebook to San Diego's Balboa Park proudly declares, "The museums function as a miniature Smithsonian Institution for students of anthropology, archaeology, art, and natural history."[10] Nevertheless, at the start of the war, the US Navy assumed control of Balboa Park and the city's most popular museums—including the San Diego Museum, Fine Arts Building, and Natural History Museum—and closed them for the war's

duration. Collections were packed up, and specimens, paintings, and objects were temporarily housed in nearby warehouses.[11] Situated not far from the coast, the museums were thought to occupy a location that was vulnerable to attack, and objects were moved for safekeeping.

The Smithsonian was not the only museum contributing to the war effort. Art, history, and science museums from New York to Cleveland began issuing public statements and meeting to discuss how they might contribute. On December 21, 1941, just two weeks after the bombing of Pearl Harbor, the Association of Art Museum Directors (AAMD) and the American Association of Museums (AAM) issued a joint resolution that US museums were ready and willing to help in working to win the war. They also promised that museums would work to stay open and redouble their efforts in educating the public, concluding, "They will be the sources of inspiration illuminating the past and vivifying the present. . . . They will fortify the spirit on which Victory depends."[12]

Early in 1942, the Smithsonian organized a War Committee to fulfill the stated promise to support the war effort, mirroring the many other war-related committees and volunteer organizations starting to appear in other arenas of US cultural and social life. These boards possessed uneven power and influence, but similar committees were formed at local levels to administer rationing, labor, and conscription.

Two individuals at the Smithsonian, the institution's secretary, Charles Greely Abbot, and an engineer who became head of a newly created War Committee, Carl W. Mitman, worked especially hard to determine future directions during

the war. They sought to establish how the Smithsonian could contribute to the war effort and move the large institution in new directions.

The War Committee

An initial problem for the Smithsonian's War Committee was that staff remained unclear what exactly its purpose might be. Despite uncertainty, however, the committee gradually began the process of trawling the museum for specimens and ideas to aid war agencies—a complex and ill-defined project with aims that only came into focus later in the conflict.

In April 1942, Smithsonian leaders agreed to explore ideas for new exhibitions on war-related subjects. The committee immediately provided facility use, access to specimens, and funds to create new displays. Perhaps more significantly, collections and curatorial knowledge had already quietly begun being placed at the disposal of the war agencies.

The museum's secretary, C. G. Abbot, was an astronomer and a leading scholar who studied the sun. Abbot made his reputation as a scientist in part due to his work in setting up international field stations around the globe, working to measure solar radiation in a consistent fashion. Arriving at the museum in 1895, he rose to assistant secretary in 1918, and by the US entry into World War II, Abbot had been secretary for over a dozen years. He noted an increase in requests for information related to national defense even before the US entry into the war.

Following the attack at Pearl Harbor, the museum reported, "calls upon the Institution for special information relating to the war increased rapidly." Abbot quickly appointed the new committee, "for the special purpose of exploiting every facility of the Institution in aiding the war effort." He added, "Such a highly specialized organization as the Smithsonian obviously can only undertake those things which its staff is trained and equipped to do, but the exploratory investigations of the War Committee revealed a surprisingly wide range of activities in which the Institution could engage that are directly or indirectly of real service in the war efforts."[13] The committee appointed by Abbot included a wide array of Smithsonian curators. The chair, Carl W. Mitman, was an engineer and curator who had gained a national reputation as an expert in timekeeping. The membership also included William N. Fenton, a young anthropologist and specialist in American Indian cultures, and the chief of the Smithsonian's editorial division, W. P. True.[14] For several weeks following the committee's formation, it met daily to hasten efforts to organize the large museum network. Questionnaires were circulated to museum staff collecting information about expertise and travel experience.

Behind the scenes at the museum, things were starting to stir. By May 1942, the Smithsonian committed to publishing the *War Background Studies* series. The pamphlets were intended to provide war agencies with expert knowledge held by Smithsonian curators. Letters soliciting draft manuscripts requested that "these papers should include a discussion of

the peoples, history, geography, and perhaps something of the natural history of the area concerned."[15] Between coordinating the large surveys, dealing with the mounting number of requests, and organizing the new publication series, the committee suddenly had its hands full. For all of the shifts taking place behind the scenes, most visitors to the museum were unaware of the depth of the Smithsonian's wartime turn.

From Creating Knowledge to Disseminating Knowledge

Following the staff inventory in 1942, which charted each researcher's expertise, the War Committee took its first clear steps to aid the war effort. A detailed roster was compiled, including nearly one hundred scientists working in the museum complex, "listing their geographic and specialized knowledge." Following this, the museum began a log registering each request received from war agencies. During the first six months of the war, the museum received 460 requests for information. Half of the inquiries, it was noted, came directly from the War Department or the Navy. The museum concluded, "In short, the Smithsonian is serving as an important source of technical and geographic information."[16]

Although assisting war efforts to such a degree was a new undertaking, the Smithsonian envisioned its efforts as "in line of its normal functions of diffusion of knowledge."[17] Existing projects, including the institution's long-running radio program, titled *The World Is Yours*, temporarily shifted emphasis to seemingly more pragmatic subjects.[18] Existing exhi-

bition spaces were retrofitted to include special war exhibits and news releases written by the museum. Spaces previously emphasizing the museum's independent research efforts now served as sites for disseminating war-related information. News releases were temporarily rebranded as "War Background Data."

Despite the clear emphasis toward lending a hand to war agencies, in 1942 the museum noted that only about 10 percent of its staff was engaged in full-time work assisting the war effort. Some staff members stayed at the museum, while other moved full-time to war agencies.[19] By 1943, this number had grown to thirty-three employees.[20] The Smithsonian made special efforts to articulate how and why its expertise and resources might be used in this way. The annual report for 1943 built on earlier rhetoric justifying the museum's involvement in the war by stating, "the war time policy of the Institution has been to use all its resources in winning the war, while continuing insofar as possible the recording and publishing of essential scientific observation and such curatorial work as is necessary for the proper care of the National collections."[21]

Public documents only hinted at the depth of the relationship suggested by more internal, archival records. During the war, most information requests from the Army related to culture and global history and were therefore directed to anthropologists on staff. Questions were directed to the Smithsonian on topics ranging from West African witchcraft to Hindu caste markings. Information about native means of sustenance in Asia was also gathered, with the hope that such

information might help stranded aviators. Some questions had more obvious implications for war, while others seemed more indirect in practical significance. The Army requested photographs and linguistic information related to the South Pacific, where the fighting with the Japanese was raging, but it also requested a list of references to authorities in the language of the Yaqui people of northern Mexico.[22] Rarely did the military elaborate to Smithsonian staffers on the rationale for such requests.

Museum Collections and War Agencies

About a year into US involvement in the war, government agencies were not only turning to the museum for staff expertise but also exploring museum collections, hoping to gain insights about topics ranging from Indigenous cultures to mineral geology. The Smithsonian already possessed an unparalleled depth and diversity in collections—the vast majority never displayed publicly. To an astonishing extent, during the war, which vaulted the US military to its position as the largest and most sophisticated in the world, planners continually turned to old knowledge for new ideas. In order to maintain military prowess, officials examined numerous Native technological traditions recorded in the museum. Not only was information about linguistics and ethnography at their fingertips, but the US military sought to learn from traditional, Indigenous techniques for weaponry and transportation.

Many US military requests to view anthropology collections revolved around challenging deployments to cold climates. Boats, canoes, parkas, travois, snowshoes, and objects for working animals were all carefully, if sometimes informally, scrutinized. It is unclear to what extent the US military utilized the Indigenous techniques of arctic peoples in designing new cold-climate equipment, but it is certain that officials took a keen interest in the Smithsonian's collections for this purpose. The military even requested microscopic samples of a wolverine skin used by arctic peoples to make warm coats.

Similarly, the Smithsonian received requests to view either photographs or actual material culture specimens from the Pacific Rim, especially the Pacific Islands, where the US military would ultimately force the Japanese military to withdraw, occasionally interacting with Indigenous peoples caught in the war's crossfire. Requests were made to learn from scientists about biology and other natural history collections, such as poisonous plants. Military officials also requested to view a wide range of objects from the Pacific Islands. In addition to extensive language information, the Smithsonian provided photographs of Burmese houses, as well as information pertaining to native foods in the region for stranded military personnel.[23]

Although archival records indicate that US military officials did, on many occasions, visit the Smithsonian to view material culture collections, it is unclear how much time officials spent examining collections in museum storage.

Military officials also probably examined material on exhibition in the Smithsonian; however, no records detailing these activities appear to have been produced. Given the research requests' nature, military officials were strikingly open-minded about how historical material culture objects might assist thinking in developing modern solutions for effective fighting. Museum collections closely examined by military officials provided distinctive aid to the war effort and a new, albeit potentially dangerous, type of participation in civil society for museums.

Compounding the information provided to top war agency officials, through behind-the-scenes museum collections tours, were efforts made by scholars scribbling away at publications intended for somewhat-broader consumption. These scholars, most based within the Smithsonian itself, would produce publications with varied effect.

War Background Studies

The War Committee's centerpiece was the *War Background Studies* series, a largely forgotten collection of twenty-one pamphlets, ranging widely in both size and scope. The pamphlets examined subjects thought to be of utility for war agencies, ranging from ancient histories to more practical guides regarding various flora and fauna encountered in specific geographic areas. Most pamphlets were assigned titles indicating their relation to a particular region, but the concerns and expertise maintained by the authors meant they addressed regions that

were interesting to the war agencies from differing perspectives. Smithsonian staff members, including archaeologists, linguists, and botanists, each approached distinct regions with a different methodology and concerns. The pamphlets were intended to fill in gaps in popular knowledge about these regions and were therefore written for general audiences rather than experts. The anthropologist and historian David Price has described the series as "mostly a mixture of geographical and cultural information with no unifying organization of direct military application."[24] Indeed, portions of the series, especially texts focusing on specific cultures or geographic regions, possessed obvious use, while those exploring more philosophical questions (one book was on the evolution of nations, for example) might have been less valuable for direct wartime application. Furthermore, internal documents at the Smithsonian generally rate the influence of the works as either widely varied or totally unknown. Although the series helped to contextualize parts of the globe, including, following an example explored by Price, the Suez Canal, they did little to interpret the military or strategic significance connected to different locations or populations.

The *War Background Studies* series varied widely in subject matter and probable utility for government agencies. At best, the impact of the series can be rated as moderate. Many of the booklets were largely overlooked by people other than specialists. Nevertheless, the perception of contributing to the war effort through scientific knowledge was deemed critical.

Ideas about Museums, War, and Peace

Despite only having a partial vision as to the wide range of wartime activities engaged in behind the scenes at the Smithsonian, writers and museum leaders reflected intensely on the state of museums during and after World War II. At the start of the war, a museum educator named Theodore Low published a brief article titled "What Is a Museum?" The article argued that museums had not kept pace with a rapidly changing world. Low contrasted public museums in a democratic society with the government-run media gripping societies in fascist nations. Although both were essentially propaganda tools, one was based in truth, while the other was based in falsehoods. Low wrote,

> No one can deny that museums have powers which are of the utmost importance in any war of ideologies. They have the power to make people see the truth, the power to make people recognize the importance of the individual as a member of society, and, of equal importance in combating subversive inroads, the power to keep minds happy and healthy. They have, in short, propaganda powers which should be far more effective in their truth and eternal character than those of the Axis which are based on falsehoods and half-truths. Museums with their potentiality of reaching millions of our citizens must not fail to recognize their responsibility.[25]

While Low affirmed the museum's role in wartime, he argued, "the value of the museum in wartime must necessarily

be limited to the maintenance of morale." He continued, "It is the army and navy which will win the war. The museum's task lies in preparation for the peace time to come."[26] While Low anticipated the coming debates regarding the museum's role in democratic society, he underestimated the role that museums would play in the emerging conflict. He even underplayed the lesser degree to which museums had volunteered their services to support the war effort during World War I. His separating the museum and the military was perhaps logical on some level, but the Smithsonian would become firmly committed to the war effort during the early 1940s. Rather than a tool for war making, Low suggested that the museum in the future would assume an important role in encouraging world peace. To accomplish this goal, Low argued for the continued expansion of education departments within existing museums and new outreach methods, including the continued use of radio, to expand museum programming's visibility. Low hoped museums might find a way to merge their goals of scholarship, preservation, and education to become a more dynamic force in the modern world, oriented around the concern for global peace. He concluded, "active public museums are an American creation and as such they can play an exceedingly important role in maintaining and strengthening that thing which we like to call 'the American Way of Life.'"[27]

Many thinkers concurred with Low's vision. Museums were to contribute to the war effort through popular, morale-boosting exhibitions. Following the war, museum critics and museum professionals alike called for boosting democratic

and peaceful societies through popular knowledge gained by visiting museums. Less than a month after US entry into the war, a reporter for the *Washington Post* noted, "This importance of things spiritual has been definitely recognized by the heads of our museums."[28] Low's dual notion that museums could contribute to the making of both war and peace was powerful. The idyllic portrait of museums proposed by many intellectuals of the era, however, stands in contrast to the manner in which Smithsonian collections, resources, and knowledge were used to actually *make* war.

Two years after the publication of Low's article, the AMNH in New York began its 1944 annual report by stating, "The War has stimulated people's interest in the whole world of nature, including the various peoples inhabiting the earth."[29] The AMNH accurately predicted that the postwar political climate would bring changes to museums in the United States: "It seems quite clear that the new role our country must play in international affairs will call for an expansion of our anthropological activities into foreign as well as domestic fields. It also seems certain that the return of peace must lead to a revival of our concern with the nature of our own country, since there has been no permanent settlement of the domestic problems and difficulties which beset our nation in its relations to the environment before the war."[30]

Indeed, countless media reports and firsthand accounts about seemingly distant corners of the globe helped to stimulate a sustained popular interest in museums following World War II. Somewhat echoing war agency sentiments at the conflict's outset, many individuals in the United States became

inspired to learn about the shifting geopolitical landscape as well as the natural environment. Some patrons utilized a trip to the natural history or art museum as escapist relief from the war's anxieties, yet others embraced the opportunity to learn about cultures, environments, and events that they became curious about following wartime events. As the war concluded, the Los Angeles County Museum, for example, featured two simultaneous photography exhibits. One was war related, while the other was mostly not war related. The museum marketed the dueling exhibitions to those who sought to learn about the war as well as to those who sought relief away from wartime anxieties.[31]

Swelling attendance in northern and western cities probably had another contributing factor in the major demographic changes taking place during this era. Huge numbers of people moved from rural areas, especially from the US South, to cities across the North and West during the war. Many of these individuals gained better economic opportunities through wartime defense jobs. Starting a few decades earlier, around World War I, many Black Americans—perhaps six million in total—left the US South to move to northern and western cities in an event known as the "Great Migration." Black Americans were joined by many other migrants seeking work and educational opportunities in the expanding cities. New migrants also greatly altered the cultural and social landscapes in urban centers. Although both de facto and de jure segregation kept many people of color away from museum spaces, the overall population growth and gradual opening up of these same spaces marked a major

shift. Museums in cities like New York, Chicago, and Los Angeles all clearly benefited from the growing populations in their respective regions—a boom that lasted well into the postwar era.

In 1945, A. E. Parr returned to the AMNH in New York after a leave of absence. In returning to his post as director at the AMNH, Parr made observations on the museum's present state. Parr was fearful that his museum would lose ground gained during the war years. He hoped to continue this momentum by initiating new programs. New Deal programs had allowed collections to be reorganized during the Great Depression. Curatorial staff (often eager to build new collections through fieldwork) were forced to turn inward for research, and rising attendance figures progressively led to growing budgets and new exhibitions and facilities. While the era had seen clear leaps forward, museums at other key moments seemed in danger of being left behind or swallowed by the turbulent problems of the era. Parr argued that the worst thing to befall natural history museums following the war would be to succumb to the temptation to forget everything that happen during the war years: "To see as the goal of reconversion only a reversal to an earlier state of happier memory, and to seek mainly the reestablishment of previous contacts with fellow sufferers rather than attempt to reenter the turbulent main stream which left them on its shores for a while. This is the deepest pitfall across the path of the natural history museums today."[32]

Parr resisted making the claim that museums could guide the world into permanent peace and harmony both among

differing cultures and between humanity and nature. His focus was more pragmatic and perhaps more realistic. Natural history museums, he advocated, should stick to what they knew best. For Parr, natural history museums knew how to contribute to the scientific understanding of the world and to educate the public about this understanding. Parr wrote, "The world will truly be at peace only when the peaceful arts and sciences have fully returned to their rightful place in the thoughts and actions of the people," and it was the museum that would guide people to these peaceful thoughts.[33]

Parr was disconnected from the depth of the Smithsonian's confidential involvement with war agencies, failing to witness the museum's full entry in war making. Although the Smithsonian would proudly announce its involvement in World War II in annual reports, its widespread efforts toward assisting war agencies in conflict appear to have been largely short-lived. The exact manner in which museums in the United States would engage civically with the federal government remained largely unarticulated, but it was clear that the museum was moving in new directions. At war's end, museums again turned their attention to meeting the educational desires maintained by public audiences. Two years earlier, when Chicago's natural history museum was celebrating its fiftieth anniversary, Stanley Field, the museum's director, predicted,

Our soldiers and sailors who are now having the exciting experience of seeing strange and exotic regions and races will, on their return, retain their world-wide interest. . . . Think-

ing people will turn more and more to the natural history museums in their quest for knowledge about races, regions, customs.... [The] Field Museum is a microcosm of the basic realities of this world. Embraced within the scope of the four great natural sciences to which it is devoted—anthropology, botany, geology, and zoology—are the fundamental elements of everything in life, and the causative factors that make people and other living things what they are.[34]

Museum-based intellectuals recognized both the power and the problems in the museum idea at war's end. Francis Henry Taylor, an eminent curator and museum critic, argued in 1945 that "if the term 'museum' strikes terror to the heart of the average layman, it is nothing compared with the sense of panic which its sound produces in the poor innocents who spend their lives rationalizing its very existence."[35] Taylor argued that museum methods had grown tiresome to the average museum visitor. Despite this, he argued, museum audiences continued to grow. To continue this positive development, Taylor wrote, museums need to embrace science and liberal arts in a manner enhancing democratic society. Taylor argued, "Here then is the final and basic justification for the museum . . . to be the midwife of democracy."[36] He concluded, "We must look to the study of man himself, and we must recognize that education is no longer the prerogative of an initiated few, but the vital concern of the community at large."[37]

In 1948, the *Atlantic* published a talk by the syndicated newspaper columnist Walter Lippmann, which he presented

to the American Association of Museums annual meeting that same year. Lippmann, as a journalist, had long been concerned with the relationship between the media and democracy in the United States. In his essay on museums, titled "The Museum of the Future," Lippmann contrasted the Huntington Library's serene galleries with the chaotic and newly reopened art museums found in Berlin. Lippmann argued that museums had become sanctuaries, mere domiciles for artistic masterpieces, at risk of becoming obsolete in a dangerous modern world. If only more masterpieces existed, the author lamented, more people would have an opportunity to benefit from viewing them in person. Lippmann asked whether more people might benefit from viewing works of fine art if museums were more willing to create and display replicas. Indeed, for Lippmann, as for museum-based intellectuals in the immediate aftermath of the war, museums had an opportunity to play an important and expanded role in a democratic society.[38] Although Lippmann's arguments related more to art than to the natural world, his statement on museums, like those of Parr and Low, argued that museums could help restore peace in a modern world emerging from the destruction of war. In the 1920s, Lippmann had expressed grief over the attentiveness that the public was willing to give to motion pictures, while zipping past masterpieces in museums of art.[39] Despite his misgivings about the abilities of the public to fully appreciate art, Lippmann considered museums as important for maintaining heritage and cultural treasures in the contemporary world, and this opinion appears to have been solidified by World War II's many tragedies.

During World War II, a lumbering goliath steeped in Victorian traditions moved to action. The Smithsonian Institution embraced the opportunity to become a tool for making war in the hope of emerging as a stronger force in democratic life in the United States after the war. To a certain degree, the intervention worked to raise the profile of the institution and place it in a more central role in shaping life in the United States. Not only did free visits to the Smithsonian make a mark on soldiers stationed in the capital, but publications stemming from the war still sit on library shelves, some having made important contributions to the meager available literature on certain regions and peoples. The Smithsonian had, somewhat unintentionally, managed to reshape itself as an institution defined by current affairs as much as an institution shaped by history, culture, and natural sciences. Government officials became familiar with museums and their collections as a resource. At the same time, efforts to understand the exact utility of the programs instituted by the Smithsonian's War Committee remain shrouded by some uncertainty.

Information regarding how military leaders implemented knowledge drawn from collections is scant. Measuring government officials' reactions to the publication series is also a challenge; war agency leaders were not publishing reviews in academic journals for future historians. Further, the Smithsonian's involvement in World War II effort was never an official series of tasks, nor did the museum take the opportunity to critically reflect on the appropriation of museum objects made by Indigenous people or natural history specimens for

making war. Rather, the museum simply described its own involvement as "a deliberate effort to make its resources of the greatest possible usefulness in the prosecution of the war."[40]

At war's end, however, curators and intellectuals, most completely unfamiliar with the Smithsonian's unique engagement in wartime activities, conceived of postwar museum survival as dependent on a different kind of public engagement, one more peaceful and based on perceived community needs, rather than centering on the nation-state-oriented needs in making war. Ideas about the nature of war shifted radically during the nuclear age. But conceiving World War II to be "total war" allowed the Smithsonian to deepen its participation in the conflict. Whereas many factories and plants retrofitted during the war to produce weapons essential to the Cold War military-industrial complex, museums like the Smithsonian largely returned to their previous missions connected to research and popular education through exhibition. On the other hand, in the conflict's large wake, museums were pushed toward shaping emergent US ideas about internationalism and universalism, encouraging the public to envision the world as possessing a shared natural environment and a collective global humanity, despite distinct cultural differences. A handful of museum leaders and commentators, like Alfred Parr, wrestled with this tension as they attempted to remake the postwar museum.

In addition to the lasting legacy of reshaping the museum into a center for understanding global affairs through anthropology and natural history, the Smithsonian responded to the war with a publication series that left a mark for de-

cades. Although the museum claimed that the *War Back-ground Studies* series was widely disseminated throughout the federal government and among soldiers who desired these publications, many works only experienced a marginal degree of popular influence. Despite John F. Embree's publication of *The Japanese* in the *War Background Studies* series, for example, the anthropologist Ruth Benedict was invited by the US Office of War Information to write a similar volume on the history and culture of Japan, which became the now-classic book *The Chrysanthemum and the Sword: Patterns of Japanese Culture*.[41] First appearing among the many other social scientists who provided the government with particular insights during the war, Benedict's book emerged to hold a significant place in the canon of US anthropology.[42] The influence of Embree's scholarship, on the other hand, was mainly confined to specialists. Benedict's study, based largely on her interviews with Japanese Americans, was begun in June 1944, well after Embree had published his pamphlet, which was based partially on his ethnographic fieldwork in Japan. Not only had Benedict never been to Japan, but she was previously unfamiliar with the Japanese language and culture. Benedict even relied heavily on Embree's work in her own book.[43] Although Embree's pamphlet published for the Smithsonian's *War Background Studies* series was later expanded into the book *The Japanese Nation: A Social Survey*, his work would never enjoy the popular and scholarly attention given to Benedict.[44] Certainly, Benedict benefited from the advantages of a strong position in the field of US anthropology, having studied under the eminent scholar Franz

Boas at Columbia. She also possessed a knack for clear and lucid writing, reaching beyond purely academic or specialist audiences.[45] Likewise, several other pamphlets in the *War Background Studies* series experienced a relatively short-lived influence despite republication.[46]

As many museum leaders outside of the Smithsonian considered the modern museum "dilemma," most failed to consider the full extent to which the nation's largest museum contributed to the war effort. Francis Henry Taylor, Theodore Low, A. E. Parr, and Walter Lippmann all failed to recognize the Smithsonian's war effort as a contradictory new component of the museum's role in modern society. Instead, intellectuals came to renew a vision for the museum as a vehicle for peace as well as environmental and cultural preservation.

Certainly, the Smithsonian's direct involvement in wartime activities calls for robust critique and careful consideration. Museums went to great lengths to become more pragmatic during World War II. The question remains as to why so little resistance appeared in regard to the decision to turn the museum into a tool for total war. It is also unclear how many of the military's requests found any use in practical application. What is clear is that the museum's vitality as an institution in the United States depends heavily on choices made regarding pragmatic relevance to modern society. Museums have continued to embrace current events or crisis moments as an opportunity to educate the public. Today, museums respond quickly to news about war, disasters, and scientific discoveries as opportunities to educate and capture popular interest. The Smithsonian's connection to other government agencies

and its role as an adviser in heritage preservation during re-
cent conflicts in Iraq and Afghanistan illustrate that these
questions remain highly relevant. In complex ways and with
uneven results, World War II served as a major turning point
in the development of these trends, pushing museums to
become increasingly responsive to a rapidly changing world
rather than mere closets for arcane knowledge.

1970 Art Strike and New Museum Perspectives

It was a warm spring day during a tense time in the city. On May 22, 1970, nearly five hundred people protested by sitting on the steps of the Metropolitan Museum of Art in New York City, partially blocking its main entrance and drastically reducing attendance to the nation's most prominent art museum.[1] The protesters called for the withdrawal of US troops from Southeast Asia. The museum was celebrating its centennial and expecting a big, busy year, but protests such as the one taking place in spring 1970 had not been part of the plan. A tense showdown between museum leaders and protesters was set to face off, with no clear resolution in sight.

The casually dressed crowd was composed of artists, students, and a hodgepodge of other supporters. They charged that the museum failed to stand with them in solidarity against "war, racism and repression."[2] The protesters had rejected an offer from the museum's vice director to shut the museum for an hour in response to their demand for recognition.[3] Less than a month earlier, President Richard Nixon had gone on national television to announce the expansion of the US military campaign into Cambodia. The protesters wanted people of color from around New York to be repre-

sented in major galleries. The protesters demanded that art obtained illegally from American Indians be returned. Finally, they wanted to see a greater number of artists on museum governance boards. While the strike failed to achieve these goals or even successfully close the museum for the day, it foreshadowed many intense debates about museums and their role in society in the late twentieth century.

During the controversial art strike happening over the summer of 1970, many students and artists began to reflect on their role in broader society. They also, understandably, wanted to be able to make a living as artists in an era in which philanthropic and corporate support for modern and contemporary art museums seemed to balloon. The museum's role as a monied institution came under scrutiny as connected to this conversation. Museums, their investments, and the names and respective social positions of their trustees also encountered more public examination.

Artists were not only thinking about the place of art as a raw commodity for galleries and museums. They were also finding their voice concerning the Vietnam War. Many were staunchly opposed to the conflict, its expansion into Cambodia, and the draft. They were also considering how museums acquired their collections and how they might proceed to do so more ethically.

The art strike suggests that the modern museum could potentially face different types of crises, one set brought on by external factors such as flood and public health crisis and still another series of factors that were more broadly existential: Whom does a museum serve? How should it be

funded? Where should the objects in museums come from, and whose stories should they tell?

Protests seemed to be happening all over the city. By late 1967, an organized protest movement resisting the Vietnam War was gaining momentum. Thousands attended peace rallies in Central Park during the summer in 1968. In December 1969, the United States began the first draft lottery since World War II. Public opinion, already divided on US involvement in Vietnam, began to truly sour. By spring 1970, tensions surrounding the war were at an all-time high, spilling onto college campuses and city streets and into cultural institutions like museums. The Kent State shootings in Ohio on May 4, 1970, heightened the tensions and raised the stakes surrounding the growing protest movement. Just two days before the art strike, another one hundred thousand voices were raised in New York City by much more conservative protesters. They expressed their support for the Nixon administration by marching in favor of the war. Collectively, these events added to a general feeling of uncertainty and division in many places across the nation.

When strikers collided with art museums in 1970, how successful were they in achieving their goals? To what extent was their protest simply a carryover from the turbulent 1960s, and to what degree did their intersectional calls for change represent something new? Finally, how was the event perceived at the time by both the media and the museum leaders who responded to the chants, fliers, and sit-ins?

By spring 1970, big new plans were coming into place for the summer. On May 22, 1970, the Art Workers Coalition

(AWC) called for an all-day strike at and around museums and galleries in the city. While the movement was perhaps only partly successful in achieving its goals, people were suddenly paying attention.

The Met and Museum Origins in New York City

The Metropolitan Museum of Art (also known at the Metropolitan or simply the Met) emerged at the outset of a wave of museum building and expansion taking place in major cities in the United States.[4]

Founded during the earlier chapter of museum formation in the nineteenth century, the Metropolitan Museum of Art had grown into a nearly encyclopedic collection of human artistic expression during its first century in existence, but since World War II, museums had steadily experienced a quiet but dramatic growth in both size and number. This was reflected in a steady growth in attendance figures at many institutions across the country.

Many major museums in US cities emerged in the late nineteenth century with a dual emphasis on scholarly production and popular education through exhibitions geared around displaying objects. The American Museum of Natural History became a leader in discoveries in paleontology through funding major new expeditions in the US West and overseas in Asia. Boston's Museum of Fine Arts, working with Harvard's Fogg Museum (now part of the Harvard Art Museums) and the Isabela Stewart Gardner Museum, worked to innovate early programs in art conservation, help-

ing to preserve and restore museum objects in need of treatment or repair.

The evolution of art in this era was not without controversy. In 1913, when modern art was displayed at the New York Armory Show, the exhibit shocked audiences and turned several artists into celebrities. When the show moved to Chicago, some newspapers objected, especially to the nude images. Some argued that children should be banned from viewing the gallery at all. An article in the *Chicago Tribune* criticized the art in the show as working to "obliterate the line which has heretofore distinguished the artistic from the lewd and obscene, and incite feelings of disgust and aversion."[5] In the 1910s and 1920s, when the Met chose not to spend endowment money to purchase American art, going against the terms of the original monetary gift, many local and regional artists objected.[6] In 1921, when the Met exhibited a group of postimpressionist paintings, rumors were circulated (some even on anonymous printed fliers passed around the city) that the "degenerate" art had been part of a secret Bolshevist plot to destroy social order in the United States.[7]

By the 1930s, however, even as museums remained popular, their role in knowledge production became gradually less central as universities assumed growing importance.[8] During World War II, universities and corporations gained prominence in areas like weapons research, aeronautics, and language teaching. These were all aspects of society that seemed to have gained more importance in the Cold War world, thereby lifting the overall influence of universities and corporations in society as compared to other institutions.

Museums, on the other hand, seemed to simply resume their role as educational institutions. They perhaps, as some historians have argued, emphasized their institutional role as "exemplary, transcendental in character, focused not on social discord, but on apparently universal agreement."[9] Earlier debates, however, suggest that museums and the proper nature of their missions were never a fully agreed-on concept.

An even larger number of museums opened during the decade of the 1970s. The postwar economic boom lasting up to the 1970s influenced museums in key ways. Visitors poured into galleries, hundreds of new student projects began in college museums, and outdated lighting was upgraded. Improvements to glassmaking led to more attractive and larger cases to display objects. Many museums became better financially resourced through an expanded tax base, increasing philanthropic support, and growing visitor numbers.

By 1970, the Met and numerous other museums were finally acknowledging that it was time to look in different directions. The Met's annual report that year read,

> The first century of The Metropolitan Museum of Art was characterized by an intense period of collecting, an amassment of works of art spanning the entirety of man's history. This collecting was accomplished by purchase, by archaeological excavation, and by the gifts of thousands of generous donors. Education and teaching of the public, although by no means absent in those years, in general took a subsidiary role. As the Metropolitan begins its second century, its course is clear. The period of quantitative amassment has

closed; the epoch of education and communication has opened in earnest.[10]

In spite of this rhetoric, the museum continued to acquire new collections. When the banker Robert Lehman died in 1969, the museum acquired twenty-six hundred artworks reflecting his personal interests through his foundation.[11] The museum had also developed ties with institutions of higher learning in the city. Also in 1969, however, an article in the museum's bulletin called on the institution to recognize the city's growing Black and Hispanic communities, arguing that the museum could do much more to reach them through exhibitions and programming. "The Metropolitan Museum of Art," challenged the article, "must begin thinking of itself as an activity, not only as a structure."[12]

That same busy year, the museum hosted *Harlem on My Mind: Cultural Capital of Black America, 1900–1968.*[13] The exhibit's poorly considered catalog (with selections that included both anti-Semitic and racist language) and the curator's overall approach to the subject infuriated many community members. The exhibit had been created with virtually no input from Black artists or members of the Harlem community. Part of what these debates underscored was the widespread uncertainty and deeply engrained bias in thinking about what should be considered high art and culture in the museum space. The outrage sparked by this particular exhibition became especially heated and multidimensional. Members of the right-wing John Birch Society even responded to the exhibit by picketing the museum in protest.[14]

In response to this specific exhibit but also as a growing trend overall, both the Right and the Left were growing louder in their criticisms of the museum. In spite of the many changes thought to be happening in the museum world in New York City and elsewhere, some level of continuity was experienced by the Met and other older institutions. The tone-deaf and biased exhibition on Harlem served as a reflection of the lack of diversity in museum leadership and an absence of the type of expertise that might be better positioned to build programs more collaboratively, one that was more in tune with the needs of the community and more open to critical feedback in the planning process. An organization called the Black Emergency Cultural Coalition was organized in response to the situation, bringing together seventy-five Black artists and other leaders.

On the heels of the organized protests in response to the controversial exhibition, ten paintings on display at the museum were defaced on January 16, 1969, by one or more vandals. The assailant(s), who were never caught, scratched the letter *H* onto paintings hung across the museum, including Rembrandt's 1661 work *Christ with a Staff*. While the paintings all avoided permanent damage and were soon repaired by art conservators, the episode demonstrated that museum protests might become increasingly multidirectional and unpredictable in the modern era.

MoMA, Guggenheim, and Whitney: The Rise of Modern Art Museums in New York City

The Museum of Modern Art (MoMA) was officially founded just days after the stock market crash in 1929. The museum's founding seemed, at least in retrospect, to signal the arrival of New York as a major player on the global art scene. Initial efforts were fairly modest, however, and the "living museum" initially occupied just six rented rooms in Manhattan. By 1939, a building for the new museum opened in midtown. Starting with just eight prints and a single drawing, the museum's permanent collection grew to become one of the most prominent modern art collections in the world. It was the first museum in the United States to establish curatorial departments in film, design, architecture, and photography. Just as significantly, the museum hosted high-profile temporary exhibitions, displaying art that older, more traditional museums shied away from exhibiting. The museum focused not only on art forms in the traditionalist sense— the paintings and drawings that had come to dominate art museums—but also on recently imagined examples of architecture, sculpture, and photography.

Over time, MoMA's extraordinarily popular exhibitions introduced many people in the United States to art created by artists like Picasso and notable living Mexican and Latin American artists, including Diego Rivera. A major exhibition of American Indians artists demonstrated to many visitors, including first lady Eleanor Roosevelt, that Native Americans were indeed still alive and some were even creating fresh ar-

tistic masterworks, which were deservedly displayed along-side other important works in modern art. The expansion into new territory was not without controversy over art that was notably absent from MoMA's early exhibitions. In 1940, an organization of abstract artists picketed outside the museum, protesting that their artistic contributions had largely been overlooked by the museum.[15] Abstract art was soon added to the collection. MoMA expanded in popularity, according to some historians, in part because it learned how to embrace such controversies and sought to attract attention through difficult discussions about them and the added media attention that followed.[16]

Indeed, in creating a new institution to house and exhibit modern art, MoMA helped to usher in a precedent whereby such art was taken seriously among the cultured elite in New York City. The city, to this point, had been and was still grasping onto an identity as an art capital in the United States. While Paris was still viewed as *the* global art capital, New York was suddenly vying for attention on the global stage.[17] Art was being produced across the country, but many critics and later historians became fixated on the hot New York art scene.

Starting in 1922, New York University began offering art history as a dedicated field of study. Whereas before World War II, fine art and art history programs were largely confined to elite universities such as Yale, departments teaching the subjects became more numerous in the postwar era. A School of Visual Arts was founded in New York in 1947, benefiting from the higher-education boom connected to GI

Bill benefits and growing student bodies with the arriving Baby Boomer generation.[18] By the 1960s, art and art history courses were also available to students at Hunter College, part of the City University of New York. Columbia University established a separate School of Arts in 1965, becoming a leading center for training visual artists. Expanded funding, new galleries, and growing overall interest marked an emergent art scene in New York during this era. Despite the obvious growth of the art and museum networks in the city, many US artists felt themselves shut out. New York's cultural elite, including museum curators, gallery managers, and wealthy art buyers, all continued to promote the work of living European artists over the talented artists living in their own city.[19]

The Solomon R. Guggenheim Foundation was founded in 1937. The Guggenheim family had largely made its fortune in mining, speculating in booming silver mines just as they were expanding in Colorado. The family became incredibly wealthy in the process and eventually used some of this fortune to establish a foundation and, later, an art museum. In 1939, the same year MoMA moved into its new building, the Guggenheim Museum was established. Its art collection grew throughout the 1940s. In 1959, the Guggenheim moved into its own spectacular new building designed by Frank Lloyd Wright. In 1969, the museum exhibited *Works from the Peggy Guggenheim Foundation*, the first time her personal collection had been publicly displayed in the United States. Hanging on the museum walls were examples of spectacular artwork by the famed European artists Pablo Picasso, Marcel Duchamp, and Joan Miró.

In preparation for the possible art strike described at this chapter's outset, the Guggenheim stripped its paintings from exhibit walls for the strike day, thinking the artwork might be in danger. "The museum has always stayed clear of political issues," the museum's director, Thomas Messer, told the *New York Times*. "Empty walls are in themselves a sobering comment on violence and coercion of every kind."[20]

In 1930, the socialite Gertrude Vanderbilt Whitney ensured that another modern art collection would join the New York art scene when a museum bearing her name was founded. In 1966, the museum moved to Madison Avenue on Manhattan's Upper East Side. It opened exhibitions focusing on contemporary American artists. The museum added to a number of new galleries opening in the city at about the same time. These galleries offered art for sale. Having one's artwork displayed in one of the city's more prominent private galleries was a status that marked achievement for artists working in the city and beyond. Relationships and trust between artists, gallery owners, and museum curators was thought to be an important element of the arts community awakening in the city in the postwar era.[21]

Although the Whitney was already struggling with a space crunch by 1970, it represented another significant addition to an increasingly globally significant art scene. Unlike the Guggenheim, the Whitney voluntarily shuttered for the day in May 1970, recognizing the artist strike with a sympathy shutdown.

Major institutions like the Met, MoMA, and Whitney, together with the many prominent galleries around the city,

provided the platform for a vocal protest that might attract attention. Although each institution responded to the strike and corresponding movements differently, they were all ultimately compelled to respond to the pressure in some way.

Art Workers Coalition

Among the groups coming together in this era was the Art Workers Coalition (AWC). The AWC came together when a group of artists, dissatisfied with how their art had been put on display, attempted to physically remove one member's sculptures on exhibit as part of MoMA's permanent collection.[22]

As interest in contemporary art grew alongside the expanded prominence of US abstract expressionist artists and artists working in other modernist art styles, including what became known as "pop art," some of these artists were starting to experience critical and commercial success. Art was sold through galleries and auction houses, with the acquisition of one's art by a major museum seen as a credibility-enhancing development for a working artist. According to the historian Richard Cándida Smith, "The number of galleries in New York City representing contemporary art tripled between 1949 and 1977, and that growth was matched by an even larger increase in the number of one-artist exhibitions." He adds, "By the mid-1970s museum attendance surpassed admission to athletic events, and in the 1980 census, over one million Americans identified their occupation as artist, a 67 percent increase from the previous census."[23]

The AWC pushed museums, including MoMA, to begin offering a free admission day, making the increasingly elite museum available to many more community members. A Black coalition was formed within the group, bringing forward concerns voiced by African American writers and artists.

Those who were calling for change hoped to see programming altered at all major museums and art galleries throughout the city, but they turned special attention to the largest and most prominent institutions in the area, including the Met. Proponents for change often argued that they were not attacking the Met as an entity, but rather they wanted to see changes and new approaches. "All these ideas," said one critical article, "are not meant to replace what The Metropolitan Museum of Art has traditionally done, but to indicate a redirection of some of its effort toward the areas of greatest need today."[24] The stage was seemingly set for groups like the AWC and an emergent collection of strikers to grab a larger role.

By the end of the 1960s, the AWC found itself in a firestorm. The group organized a poster project in collaboration with MoMA that brought in an attention-grabbing submission. *And babies* is a collaborative work created by several artists protesting the Vietnam War. The poster uses a gutwrenching journalistic photograph documenting the March 1968 Mai Lai Massacre with the question "And babies?" on top of the work and the affirmative response "And babies" at the bottom of the poster. The text was inspired by the utterances of a US Army soldier named Paul Meadlo in response to questions from the CBS journalist Mike Wallace. Wallace

asked Meadlo if the group of Vietnamese civilians he had fired his gun into had included men, women, *and* children. Meadlo confirmed that it had. In what became an iconic moment in the exchange, Wallace asked Meadlo for further confirmation that the group of dead included babies, and Meadlo confirmed that it had. By placing the text of the interview and journalistic photograph into a new artwork, the AWC called further attention to the atrocity.

MoMA pulled funding for the project at the last minute after reviewing the winning creation. AWC doubled down, printing and distributing fifty thousand copies of the poster and in late 1969 calling for a "Moratorium of Art to End the War in Vietnam." The situation in Vietnam seemed to only be worsening, attracting a great deal of popular resistance and protest in response. When the protesting artists called for a citywide museum and gallery "strike," some institutions agreed to close as a symbolic gesture of support. The Whitney Museum and Jewish Museum, for example, agreed to close for one day in response.[25] MoMA and the Guggenheim chose to stay open but offered free admission for a single day as a gesture of partial support. The notion that artists and others might band together to disrupt museum operations, bringing attention to political issues, seemed to be lent further credence, paving the way for new action.

The New York Art Strike

Quickly gaining steam from the many protest movements happening in the era, an art strike was first organized at a

local arts community meeting held in the NYU Loeb Student Center. One thousand activists were said to have gathered, voting to support the action by show of hands and electing the minimalist sculptor Robert Morris as temporary chairman.[26] Morris was born in Kansas City in 1931 and moved to New York in 1959, studying art history at Hunter College. Morris's large installations would go on to transform entire rooms and outdoor spaces in US and UK museums in the 1970s. Morris was already an established and respected artist by this point in his career, positioning him to emerge as a leading voice in the protest.

The strike movement was capped off on May 22, 1970, when five hundred individuals sat on the steps at the Metropolitan Museum of Art, protesting the museum in its present state. They arrived at the museum in the morning, before 10 a.m., so that protesters could begin setting up at the entrance in an effort to block it before the morning rush. The protesters had called for resisting the "Four Horsemen" of the 1970s: racism, sexism, repression, and war (although sexism was later described as having been added as an afterthought).

The Jewish Museum, Whitney Museum, and more than fifty art galleries closed in a widespread sympathy strike.[27] Other museums, too, had acknowledged the strikers' concerns about the war and a lack of diverse representation in galleries. Not all museums had been sympathetic in their response. The Guggenheim Museum's director, for example, "refused permission for political activities on the grounds that his museum existed 'for art exhibitions only.'"[28] The Metropolitan Museum of Art had remained mostly silent but of-

fered to extend open hours rather than shut down on the day of the strike. With such a large and diverse crowd of patrons heading to the museum each day, a strike disrupting the day's activities was sure to capture attention.

On the day of the event, visitors to the museum were greeted with chants of "Strike! Strike!" and directed to an alternate entrance. The strike remained orderly and managed to choke off crowds from the museum's normally busy main doorways. The strikers proclaimed that they did not intend "violent behavior of destruction of art or property." They were banned from the museum anyway. They remained in peaceful protest on the museum's steps as the morning wore on.[29]

Artists placed a wreath connecting their movement to other antiwar and civil rights protests happening in the era. The wreath was labeled, "Kent State, Jackson State, Orangeburg, S.C., and Augusta."[30] Indeed, these tragic events would have been fresh in the protesters' minds, the Kent State and Jackson State shootings having taken place just days earlier in the month. Some participants were energized by the group's commitment to peace; others were put off by the "negativism" and "coercive" tactics put forward by the protesters. One unnamed defector told the *New York Times* anonymously that the "group's claim to speak for everybody" was especially problematic.[31]

The Met's vice director, Joseph V. Noble, was sent outside to discuss the situation with the protesters. He told the crowd, "I respect your position and sincerity, but the museum has a great deal to offer and we feel our staying open is a positive gesture."[32] The thirty-nine-year-old Morris rejected the

museum's overtures. Despite the disruptions, the museum remained open, and about sixteen hundred visitors toured the exhibitions on the day of the strike. Although the strikers had shut down the museum's main entrance and choked off many visitors who hoped to enter the galleries, school groups and others were allowed to enter the museum through a side entrance.[33]

Initially, demonstrators considered protesting at another museum, either MoMA or the Guggenheim. "At least the other museums have made some gesture towards us," explained an exasperated Morris. MoMA had indeed suspended its $1.50 admission fee for the day.[34] Programming was now geared more toward city youth, and the institution seemed open to at least engaging in a dialogue with protesters.

Other museum leaders and gallery owners feared that the art strike might grow violent or unruly, potentially even damaging valuable works of art. The art strike ultimately did no such thing, but despite attracting a good deal of attention and some temporary action, the strikers were only partially successful in calling attention to the numerous problems facing museums in the closing decades of the twentieth century. Left unresolved, questions about power, access, money, and ethics all remained for those who were thinking about museums to address in the generation to follow.

By June 1, the New York art strike turned its attention to the American Association of Museums (AAM), meeting that year at the Waldorf Astoria Hotel in New York City. Founded in 1906, the AAM brought together museum directors, cu-

rators, and other professionals. Their meeting presented an opportunity to bring the concerns of the strikers to the larger museum world. A strike group made up mostly of AWC members managed to disrupt the meeting, pushing the group to consider some reformist resolutions. The strikers issued a press release, describing their protests as "a series of actions to end racism, sexism, repression, and war." The statement added, "As united artists, we mean to change the existing structure to meet our needs and the needs of the larger community." The group made eight demands. The first boldly stated, "The AAM must declare the immediate withdrawal of all U.S. troops from Southeast Asia as the most pressing cultural and national need of our times." The group also called for all cultural institutions to stand against war, racism, sexism, and repression. They insisted that the AAM instruct members to conduct a careful investigation aimed at reconsidering museum expansion plans, like those in place at the Met, "to determine if such plans are truly relevant to the present community needs of black, Puerto Rican, and other minority peoples, the culture of the future, and the requirements of a sound ecology." The group further demanded, "The AAM must request all historical societies and museums to remove exhibits celebrating the conquest and enslavement of black, brown, and red people" and return "examples of American Indian art and living religious art forms obtained illegally." Finally, the group demanded that artists have a bigger presence on museum boards, with the goal of eventually stripping power from museum trustees. "Museums must become working, living centers of community and cultural life

administered by artists, students, and community people." They hoped to see the AAM agree to these demands during its present convention.[35] The museum directors, perhaps predictably, ignored many of the demands.

On June 14, eighteen members of the group entered the Guggenheim. They gathered in the museum's architecturally striking rotunda. They threw leaflets into the air, unfurled a massive "Peace or Death" flag from the upper tier of the spiraling ramp rotunda, and scrawled (in washable paint) "Universality" on the wall. The group claimed that museum visitors were "delighted with the diversion," but the museum administration was not similarly amused. "Still," the *New York Times* reported, representatives from the museum's administration "later met with a delegation of [protesters] 'to exchange ideas,' and explain the Gugg's budding community programs."[36]

On June 16, some members of the group went to Washington, DC, to bring their views to the Senate Subcommittee on the Arts and Humanities. "We didn't want any more lollypops," Morris defiantly told the *New York Times*. After having been asked by senators how they could help, the artist Robert Rauschenberg was reported to have snapped, "Put on more government shows we can withdraw from."[37] Rauschenberg's comment may have come off as glib, but the postwar prevalence of government grants and public showings of contemporary art would arguably loom so large as to shape the art being produced in the era.[38] Government-sponsored art tours were a key element contributing to what historians have often described as the "cultural Cold War," or the on-

going battle for cultural influence around the globe in the postwar era. The significance of these shows as a forum for political action and career-making opportunity for younger artists was important in this moment, so threats to boycott them were potentially serious.

On June 17, the strikers met with an overly self-assured Tom Hoving, the director of the Metropolitan Museum.[39] The strikers demanded that the museum take a publicly antiwar stance. Present at the same meeting was the museum's president, C. Douglas Dillon, who replied to the strikers that such a stance would not be institutionally "appropriate." Dillon had been the US ambassador to France and secretary of the Treasury under John F. Kennedy. He had even been on the President's Executive Committee during the Cuban Missile Crisis. Dillon calmly dismissed the demand for change at the Met, stating that the individual trustees were free to make their political viewpoints known. It was an uninspiring answer, to say the least. The strikers hoped to see the museum's lobby opened up for free exchange. Instead of expanding its already massive building, they argued that the museum should create branch operations. The institution countered that it was necessary to maintain a central museum to hold an encyclopedic collection intact. It stood ready, the museum stated, to provide other museums with exhibit material through loans.[40] Again, the answers seemed partial and mostly unsatisfying to those who sought more radical reform. Still, the sit-ins, takeovers, attempted shutdowns, and aggressive leafleting had attracted attention, as had the collective withdrawal of artists from major upcoming art shows.

"I disagree with some of the tactics," said the gallerist Klaus Kertess, but the community of artists and one's place within it remained important, if not crucial. The art business, whether it be an exhibition at a public museum or a sale in a private gallery, was fueled largely by perception and reputation. "I wouldn't be involved if serious artists weren't," added Kertess. "But it's a large cause," he continued. "Some of the paranoia and hysteria has to be overlooked."[41] Although many people remained unconvinced, there existed no doubt that the actions and associated demands for reform had attracted attention.

"What, besides jolting a few institutions (and that's something) had the New York Art Strike wrought?" asked the *New York Times* rhetorically in 1970. "At this point, it's not easy to say."[42] More than fifty years after the events of the summer of 1970, it still is not easy to fully assess the strike and its influence. Many of the debates it worked to introduce continue to be relevant to museums today. Questions about community engagement, representation, museum leadership, and the stewardship of sensitive cultural objects remain. These unresolved matters exist for future generations to wrestle with. The fact that they had been called out and further anticipated in many respects by the students and artists demanding change was significant, however. Many participants were attuned to problems facing museums on the horizon, while also deeply influenced by the events and trends that led up to the strike. In turning their attention to cultural institutions, they forced important conversations about the relationship of museums and politics in the modern world.

The crisis surrounding the 1970 art strike in New York City was less environmental than it was existential. The actions mostly resulted in temporary inconvenience for museum visitors and staffers. Museum leadership, however, was forced on at least some level to reconsider its approach to how it engaged with the community. But no truly radical changes were made to museums. In this way, the strike hardly represented a true existential or physical threat to the museum as a cultural institution. The conversations around the role of museums at the time of these strikes and actions proved, however, to be suggestive about events to come. As we have seen, this discourse became quite dramatic at times, spilling onto the streets and porticos of museums and shaping daily operations. Calls for increased attention to the histories of marginalized cultures and individuals, including the representation of women artists, became more strident. Protest was to become a more active component of museum life. Debates about access would further grow into new realms.

Despite the fact that New York was quickly becoming an international art hub, much more was happening in the nation and world at the time of the art strike, a fact that the strikers readily acknowledged and, indeed, emphasized in their protest. Later in the summer, the group proclaimed the existence of an Emergency Cultural Government, which proceeded to discourage US artists from taking part in an upcoming international exposition in Venice.[43] No longer, they argued, could artists take part in a cultural Cold War working to weaponize art. Both the concerns and actions of

those who took part in the activism, therefore, had become global as well as local.

As was true in earlier eras, the real challenges facing museums were not always fully recognized and certainly not entirely dealt with in the moment. Whereas museums had come into this era fearing a change in funding structures, working to expand merchandising, and orchestrating blockbuster exhibitions, attention ended up shifting to other issues. Challenges related to representation, access, and global politics simply became more pressing in the same era.

When confronted with calls for change, museums frequently deflected, to some small degree justifiably, by pointing to the progressive steps already under way. This often included reference to children's programming that would potentially be interrupted by protesters. Museums in this era became centers for political protest. Groups from the Right or Left could and did respond to the material on exhibit, charging that the art that they wanted to see represented in the galleries was absent or that the art that was displayed was objectionable to them.

The 1970 New York art strike provides further evidence that museums are not neutral spaces, nor are they divorced from the social and cultural contexts in which they exist. Museum administrators made key choices by virtue of their actions—complete, partial, and nonexistent. Even the strikers carried their own blind spots and biases, adding sexism to their list of concerns only as an afterthought. The calls to respond to critical global crises with more art shows, too, appears somewhat self-interested and misguided in retrospect.

The widespread sense of cultural crisis and prevalent calls for change in and beyond museums remained persistent well after the strike.

The New York art strike had certainly failed to completely shut down the art world, even for a day, in May 1970. The *New York Times* published richly detailed reviews of exhibitions on the same day that it also covered the strikers' most prominent sit-in at the Met. The paintings having been stripped from the walls of the Guggenheim and the reduced attendance at the Metropolitan, however, suggested that some sort of a statement had been made. The fact that the strikers were able to spotlight their cause through disruption and the introduction of reformists resolutions into the AAM meeting suggests how the actions managed to focus some national attention on their concerns.

Understanding the history of museums in this era further suggests that threads in society like art and science—things that are often cast as being separate from politics—are, in fact, intensely political in their nature. Museums increasingly served as battlefields on which national and global political contests over pressing social questions would become even more tense.

The Culture Wars of the 1980s and 1990s

Politically charged public controversy loomed large over museums in the late 1980s and during much of the 1990s.[1] Rolling crises seemed to connect museums to shifting public opinion, performative outrage, fiery contests over historical memory, and charged questions about museum ethics. Once again, the changes and challenges were frequently described by the media as being pivotal moments that presented turmoil for museums, and as before, real damage was done to cultural institutions with regard to their reputation, programming, and ability to make progressive changes moving into the future. On the other hand, newly developed exchanges resulting from the push for repatriation and improved transparency in exhibit planning improved the situation some by the new millennium.

Many arguments about museums that emerged in the art strike in 1970 would only swell into a louder and more expansive cacophony in the decades to follow. Museums continued to debate the ethics related to questions surrounding control over and display of sensitive objects, especially in light of the complex and sometimes dark histories carried by museums as institutions. Debates about museums and the presentation of history, art, and science became increasingly contested. This was especially true in media spaces. Many journalists

viewed the events as battlefield engagements in the ongoing "culture wars" crystallizing around arguments about prayer in school, the teaching of evolution, the interpretation of particular historical events, and the place of controversial art in taxpayer-funded public programs. The culture wars were also about feminism, sexuality, abortion, race, drug use, censorship, television, and a host of other heated issues in the era.

The power of mass media was arguably reaching a new zenith at this moment, both in its popular sway and also in its laser-like fixation on controversial public issues. Museums served as familiar spaces to battle social and political matters, relayed into national magazines and local newspapers. To link the mass media and museums in this way is ironic on some level, as rising literacy rates and popular media had done much to fuel the emergence of museums in Europe and the United States.[2] Now, the media's obsession with public scandal and controversies connected to the culture wars proved capable of damaging museums and other cultural institutions.

These stories are well known in some circles, as academic books and articles flooded out about these episodes in the 1990s and early 2000s. The following pages, however, offer new framings for some relatively familiar stories. Considered against the longer history of museums and apparent crisis, the stories presented here examine how issues related to repatriation, historical interpretation, artistic expression, and government funding became hotly contested in a way that defined so much about museums in the late twentieth century and early twenty-first century. Historians have argued

that museums became less culturally insulated from debates in US society in the late twentieth century. I argue that museums and their leaders did become more keenly aware of protest and political controversy in the era, and while this led to a temporary chilling effect in exhibition planning, it did ultimately push museums to become more broadly relevant to popular culture.[3] Newly opened museums helped lay bare difficult histories connected to racism, anti-Semitism and the Holocaust, American Indian genocide and displacement, and the long history of racism toward African Americans dating back to the brutal institution of enslavement. Along with reoriented exhibitions at older institutions, these new museums collectively suggest how cultural institutions were pushed in remarkable new directions after the 1990s.

How these stories are often remembered is misleading. A survey of 8,200 museums and 15,600 historic sites in this era revealed that only 8 percent of museums had budgets over $1 million, and the vast majority of museums were much smaller. Many were partly funded by cities and towns across the country. Only 4 percent of museums in existence were founded before 1900. More than half of the surveyed were private.[4] In this era, however, the larger, older, public museums attracting much of the ongoing controversy became foremost in the conversation. The discourse surrounding big-museum "controversy" arguably sucked the oxygen from the room. It became difficult to make space to address the many other problems facing museums in the late twentieth century.

This brief history does not address all of the many social and political problems in the era. HIV/AIDS, the emergent

gay liberation movement, environmental issues, and the expanding prison-industrial complex are notably absent from many conversations. Yet a surprisingly wide range of social issues became linked into museums during this era. Most often, however, a cadre of social and political issues were wedged into overly simplified arguments about history and science when it pertained to museum spaces. More importantly, major new legislation was to reorient museum work in the late twentieth century. As was true in earlier eras, those who were thinking and writing about museums often failed to see some long-range challenges in favor of fixation on dramatically episodic flashpoints, and yet the nature and intensity of the controversies pushed museums of all kinds toward reflection. This chapter begins with a new challenge to prized museum collections built over the last century, as material from American Indian and First Nations cultures from across North America came under a greater degree of scrutiny. Although challenges to these collections had existed since their origins, the closing decades in the twentieth century touched off a series of critical examinations as they related to museums.

Returning the Sacred

During the nineteenth century, millions of objects were collected from Indigenous societies for museums in the United States. Some objects were sold or donated by their Native creators, but many others were stolen, removed from graves, or otherwise trafficked in ways that revealed layers of colonial

dispossession. In the second half of the twentieth century, Native American activists, leaders, and communities began to more forcefully voice concern over the treatment of sensitive objects housed in museums.[5] In being removed from their original context and placed in a museum collection, many objects, including highly sensitive spiritual objects and items with profound religious significance, became detached from their original meanings. Bones of about half a million Indigenous ancestors were also held in museums across the United States. Another half a million bodies of the American Indian ancestors were thought to be held in museums around the world.[6] While many bodies were acquired "legally" through the auspices of early archaeology and medicine, historians continue to reveal the many ways in which these remains were gathered through a process that frequently resembles looting and genocide more than progressive science.[7] The way in which complex Native societies and individual lives became "museumified" into scientific specimens ultimately caused hurt to many Native Americans. Indigenous activists sought to rectify, or at least begin to address, many of these past wrongs through new actions.

The dark history of collecting and exhibiting human remains was especially fraught and hurtful to many Indigenous people, who came to link the practice with museum collecting more generally.[8] For decades, stretching back as far as the 1930s, tension existed about the problem of sacred material and ancestral human remains in museum collections.[9] The American Indian Movement (AIM) of the early 1970s injected new life into the effort. Museum curators responded

by publishing articles advocating for museum collections to be retained.[10] They largely sought to maintain the status quo, especially when recognizing sacred materials as rare historical objects and human remains as valuable scientific specimens. A fundamental question was at hand: Were Native bodies and their sacred articles scientific resources, human beings, or somehow both? Given the many shifts in recent decades surrounding the ethics of scientific collecting—Who might control the destiny of these bodies?—not everyone was comfortable with the prevalent answers to these pressing questions.

Native American artists soon joined the activists in calls for change. In a 1987 work of performance art by the Indigenous artist James Luna called *Artifact Piece*, the artist put himself in a typical museum-style glass case at the San Diego Museum of Man (now the Museum of Us). The installation called attention to the dehumanizing effect of museumification. Placing something under glass, making it seem precious in nature and like an *artifact* rather than a person or object, was a harmful process that distorted realities about Indigenous people. When Native American lawyers and legal activists joined in by collectively pushing for change in the 1980s, real movement on the issue began. The push for repatriation may not have been universal, but widespread activism across many tribal nations resulted in a cogent movement to push forward new legislation.[11]

Many Native communities made further steps to create tribal museums or cultural centers using the older museum model for their own purposes.[12] For many Native Ameri-

can communities, responding to the intensively colonized Western museum tradition has become an important goal, something written about by the scholar Amy Lonetree (Ho-Chunk) and others in connection to the Smithsonian's National Museum of the American Indian and tribal museums such as the Ziibiwing Center of Anishinabe Culture and Lifeways in Michigan and the Mille Lacs Indian Museum in Minnesota.[13] While some tribal museums have been critiqued as replicating the problematic colonial practices originating in older museums, many others work to decolonize the museum experience in the context of their own tribe. Commonly accepted names for American Indian objects, for example, are frequently Euro-American in origin, and in tribal museums, the original name is used. A movement was afoot for reorienting how Native American heritage was controlled and presented in museum spaces.

A critical turning point occurred with the passage of a pair of new laws in 1989 and 1990.[14] The National Museum of the American Indian Act and the Native American Graves Protection and Repatriation Act (NAGPRA) helped reorient the legal landscape for museums and Indigenous people in North America.[15] The law was just a handful of pages long, but it seemed to shake up the entire museum world. More than fifteen hundred museums, 566 tribal nations, and at least a dozen federal agencies were affected by the regulations.[16] For the first time, the law enabled federally recognized Native nations in North America and Hawaii to demand the return of sacred objects and human remains (or *ancestors*, as they are often described) from museums and other cultural

institutions. The Field Museum in Chicago returned about two thousand ancestors from its collection to lineal descendants, and the American Museum of Natural History in New York sent another fourteen thousand individuals back home, many for reburial.[17]

In a manual produced to help get new Native American delegations up to speed with the NAGPRA process, several Native authors reflected that despite the many diverse beliefs held by Indigenous people in North America, they were united in desire for change in this arena. The handbook reads, "We are all from different nations and hold different beliefs, but we share the same passion, concern and desire to see our ancestors respected and brought back to earth, as well as having our sacred items back home."[18]

One might be inclined to think that a major new piece of legislation would resolve the issues at hand. This was hardly the case. The museum anthropologist Chip Colwell reflects that the new law created anxiety for nearly all involved: "Museum professionals feared that the new law would empty museum shelves. Native Americans worried that museum people wouldn't really give anything back."[19] In the first decade of the law's existence, it was clear that the process was often bumpy. Museum professionals and Indigenous community representatives sometimes butted heads over the best treatment for material heritage in institutional collections. Despite these encounters, over time, many museum leaders and other professionals began to learn how much Indigenous leaders and elders had to offer. Ten years later, people who participated in the early NAGPRA process were left with

mixed thoughts: "The participants agreed that, although the process had not always proceeded smoothly, NAGPRA had changed the museum field and in many instances created new links between museums and Native American tribes."[20]

The laws also helped usher in the creation of new museums such as the National Museum of the American Indian (NMAI), which succeeded and brought into Smithsonian auspices the neglected George Gustav Heye Museum of the American Indian in New York City. The new laws also gave museums an important mandate. Museums were required to inventory their collections, identifying material including Native American human remains and other sensitive materials. Connecting directly with descendant communities suddenly became foundational to museum work with Indigenous creations and human remains, and many institutions found themselves ill suited to take on the emotional, fraught, and complex work of engaging in thoughtful consultation and repatriation involving such highly sensitive materials. Even with hard work and good intentions, the process would take time. Relationships needed to be built and trust established. Delegation visits began at many museums across the country. Other observers viewed the recurrent delays as intentional, representative of a lack of institutional will that in many respects might be read as a direct continuation of the original colonial dispossession. And yet NAGPRA's passage did pave the way for many changes including those extending well beyond repatriation alone. The legal changes also pushed many Native people to dig even deeper and learn more

about the museum collections representing something about their heritage, sometimes including those materials now dispersed around the globe.

Initially, however, the new law seemed to set the stage for an intense showdown over Native American culture in museums. Colwell describes how contrasting sides in the complex debate became commonly framed: "Why were Native Americans, who want to preserve their culture, so willing to bury it? And how could scientists who spent their lives studying dead Native Americans care so little about living ones?"[21] While the reality would play out much differently than predicted, the doomsday scenarios put forward by high-profile curators ensured that the crisis-colored glasses remained on when looking at museums and questions about repatriation in this era.

Other people fueled this fire by arguing that Native American remains that were ceremonially reburied had not been returned to the earth but instead ripped away from science. To them, this was less about religious liberties than about academic freedom. Throughout much of the debate, especially in the media response and the letters to the editor printed in newspapers and magazines, a sense of crisis impeded a fuller and more specific conversation about Indigenous material in museums. To a certain extent, the particulars related to complex questions about repatriation needed to wait for matters to cool down some and relationships to be established before all parties involved could successfully move forward. At the time, however, the debate was often crudely swept into broader social and political conversations.

Museums and the Culture Wars

Starting in the very late 1980s and stretching through much of the 1990s, the fever around museum discourse grew in popular culture and print media. When writing and thinking about the seemingly hotly contested debates taking place in relation to museums, many writers and thinkers began to consider this discourse in a *culture wars* framing.[22]

Published in 1991, the book *Culture Wars: The Struggle to Define America* by James Davison Hunter helped to popularize the notion that the United States was entering a time of heightened tension over its identity.[23] The book described cultural divides and social backlash against the progressive advancements made during the 1960s and 1970s. The "culture wars," as they came to be widely described in the 1990s, pit the traditionalist values of US conservatives against the progressive desires held by liberals. Still others viewed this division as dating back much further, pointing to earlier cultural divides as far back as debates about Prohibition during the 1910s and 1920s, for example. The question of whether to allow the teaching of evolution in public schools was also disputed in this earlier era, further suggesting that the contests of the 1980s and 1990s were not entirely new, even if the topics had altered with time.

While these debates all had deeper roots in US society, they seemed to become intensified as a result of modern media culture and the organization of several activist groups around museum-related protests. The debates touched on episodes in history such as war, genocide, and slavery. They

also influenced how evolution would be considered by museum audiences and thus worked to shape the response in how science exhibitions were developed.[24] By 1994, a heated debate would capture momentum from this discourse and be pushed into debate about history education standards in US public education.

Journalists used "culture wars" as a maxim to the point of cliché throughout the 1990s. The expression became an ill-defined catch-all for describing complex political and social debates, including those with multiple sides and several different vantage points. These were molded into stories about the hardening battle lines in US political culture. To a certain degree, the changing political climate had resonance with the problems facing museums and the shifting expectations held by their visitors. Furthermore, these descriptions were often overly simplified and rendered to fit the journalistic goals of the deadline-saddled author rather than a fulsome detailing of the disagreements.[25]

At this key moment, more ink was spilled over the *Enola Gay* airplane at the Smithsonian Institution than virtually any other museum object in the late twentieth century.

Enola Gay Redux

In 1994, when a three-hundred-page draft script detailing the exhibition plans for a planned *Enola Gay* display was leaked to the public, reactions to the text sparked a remarkable controversy. The planned interpretation became so hotly contested, so vocally opposed by conservative organizations,

that Smithsonian leaders felt they needed to change course, dialing back the exhibition and stripping away the controversial interpretation planned for the museum object. "The cancellation of the National Air and Space Museum's (NASM) original *Enola Gay* exhibition in January 1995," wrote the historian Richard H. Kohn at the time, "may constitute the worst tragedy to befall the public presentation of history in the United States in this generation." He continued, "In displaying the *Enola Gay* without analysis of the event that gave the B-29 airplane its significance, the Smithsonian Institution forfeited an opportunity to educate worldwide audiences in the millions about one of this century's defining experiences."[26]

The *Enola Gay*, a four-engine heavy bomber B-29 Superfortress designed by Boeing, is one of the twentieth century's most famous airplanes. The airplane was the first that dropped an atomic weapon in warfare. Named after the pilot's mother, the massive plane itself was sure to attract attention, and the *Enola Gay*'s story led from a wartime factory in Omaha, Nebraska, to the Smithsonian Institution's National Air and Space Museum (NASM).[27] Important and challenging questions remained. Had it been necessary for the United States to drop atomic weapons on Japan? Did the action truly hasten the end of World War II? What was the immediate and lingering influence on the Japanese people, and did the harms caused to human life outweigh the potential tragedy that might have befallen humanity by not ending the war as soon as possible? Does it make a substantive ethical difference if you kill masses of people using a new nuclear weapon

or if you bring widespread death to cities by firebombing them, as the US air forces did in the bombing of Tokyo? Strategically, was the use of nuclear weapons more about the end of World War II or about signaling US military superiority to new Cold War rivals?

On August 6, 1945, the *Enola Gay* dropped the bomb that eviscerated much of the town below and spread radiation far beyond the city that served as the target. The airplane remained in active service for a short time but was soon shuttled back to North America and the Smithsonian, where it remained in storage for a stretch. The massive and technologically advanced airplane seemed capable of helping to tell larger stories about the destruction wrought by modern air power but also, perhaps, what it was like to serve on the crew nineteen hundred feet above the city. The Smithsonian opened the National Air and Space Museum in 1976. Soon thereafter, the museum became one of the institution's most popular and widely visited branches. When totaling together visits to all of the Smithsonian's museums, the institution hosted about twenty-five million visitors annually around this time.[28]

Questions that spoke to human tragedy seemed to set off especially sensitive touchpoints. Photos of the dead were to be enlarged and placed as if to stare directly at visitors. A charred lunchbox carried by a Japanese schoolgirl, filled with the partially incinerated peas and rice she had planned to eat for lunch on the day she died, brought about profound reflection and heated reaction.[29] When invited to comment on revised drafts of the proposed script, both the American Legion and Air Force Association reacted negatively, touch-

ing off fierce debate. It was difficult, it seemed, to glorify the death of children even in the context of the so-called Good War in the nation's museum.[30]

"Five months before the scheduled May, 1995, opening of the most controversial exhibit ever staged at America's most popular museum," read the *Los Angeles Times*, "the emotion-soaked debate over the plane and its display has already become so politically charged and so weighted down by personal recriminations that the Smithsonian has been forced to retreat."[31] Detractors charged that the plans for the exhibition were "revisionist," or rendered the truth of the past in a light altered by present concerns. Historians and curators, by contrast, argued that history has always been constructed by continually revising the story.

"There is no glory in the *Enola Gay!*" shouted protesters in the Air and Space Museum. Large banners were hung in the prominent museum reading, "Disarm Now!" and "Remember Hiroshima." Protesters on the second floor dropped paper fliers onto museum visitors below. "I don't like nuclear weapons, but it's not the point, they shouldn't be down there protesting, I'm sorry," one museum visitor told an Associated Press video crew. Several protesters were subsequently arrested.[32] Despite the presence of anti-nuclear-war activists, it was conservative groups that proved most distressed and vocal in regard to the planned displays. Through a five-round process of revision, the museum worked with exhibit critics and stripped away contested aspects of the exhibit. For several years, the museum exhibited the airplane's fuselage alone rather than the full airplane.

The airplane became an icon, if not an effigy, representing larger debates about atomic warfare at the end of a prolonged Cold War era.[33] Was the decision to drop the atomic bombs on Hiroshima and Nagasaki the correct one? Did the massive and cruel loss of civilian life prevent the widespread loss of military life later on? With living memories still making emotionally charged disputes, rational discourse became stunted. The *Enola Gay*, it became clear, was hardly some dispassionate museum specimen.

As the controversy wore on, powerful individuals in Washington, DC, took notice. Among the exhibition's conservative critics was the Reagan appointee Lynne Cheney. Cheney had recently ended her controversial term as the chair of the National Endowment for the Humanities. Using the position, she had echoed other conservatives in attacking contemporary historians and other scholars as promoting revisionist or "politically correct" histories in their writing and teaching. Fears about possible congressional hearings in relation to the Smithsonian fiasco began to grow. In a remarkable turn, members of the US Congress began threatening to withdraw funds if exhibit plans were not changed, a warning to which the Smithsonian seemed to relent when the anticipated display was scrapped and the elected officials backed away from their threats to slash funds.[34]

Fallout

When the Smithsonian opened its new Steven F. Udvar-Hazy Center in 2003, museum leaders hoped it would be a

celebratory day. The press also carefully noted, however, that the opening of the new building finally brought to a conclusion a heated chapter in recent Smithsonian history. Among the visitors to the museum's newly opened annex that day was Sunao Tsboi, an aged Japanese survivor of the Hiroshima explosion. In an emotional moment, Tsboi came face-to-face with the *Enola Gay*, finally exhibited after years of controversy over its possible interpretation. Soaking in the presence of the aircraft, Tsboi placed his hand over his heart and then his mouth, growing emotional. He gathered himself, walked toward the plane, then broke down for a moment in tears, awash in profound feeling before collecting himself and speaking to the media about the day's significance. Protesters again appeared at the museum, following the aircraft and its story to the new building, where they held signs and even expressed their displeasure by throwing fruit in the aircraft's direction.[35]

The controversial event surrounding the planned *Enola Gay* exhibition introduced a spike in writing and thinking about the Smithsonian around the year 1995, scrutiny that would gradually dissipate after this high-water mark (although the protests and emotion on the day of the opening of the Steven F. Udvar-Hazy Center show that this emotion did not dissipate entirely by the later 1990s). The *Enola Gay* became a talisman for museum controversy in the 1990s. "In many respects," read one newspaper column from the era, "the story behind the Smithsonian's struggle over the *Enola Gay* has much more to do with 1990s cultural politics than it does with the history of World War II."[36] Experts in the

field continue to quietly disagree in regard to exactly what happened behind the scenes, the lessons that should have been learned, and to what extent a "chilling effect" followed the controversy. Some argue that the dispute over the *Enola Gay* exhibition at the Smithsonian altered, for a time, the approaches taken to exhibits at museums across the country. Arguably, however, museums were already reconsidering traditional approaches to display by this time, reorienting the visitor experience in new and important ways. Museum exhibitions were already becoming more critical, immersive, and multidimensional before the *Enola Gay* episode called everything into question.

"Call it a victory for American heritage over the forces of political correctness and revisionism. Or call it the triumph of uneducated censorship over legitimate historical inquiry," read one newspaper. "No matter your point of view, one thing is clear: The Smithsonian has all but surrendered to the veterans groups and other critics who loudly opposed the museum's initial exhibit plans on the grounds that they were wildly anti-American and laden with the scent of political correctness." The altered exhibition had watered down any potential controversy to the point of near meaninglessness: "Are [the curators] happy with the current exhibit?" reflected the Smithsonian's spokesperson. "*Happy* isn't the word I would use."[37]

Almost immediately following the controversy surrounding the *Enola Gay* and its possible public display, historians started to reflect on and write about the event. They largely viewed it as a failure in museum leadership, with museum

administrators folding in the face of pressure put forward by showboating politicians and vocal protest amplified by media interests.

In the incident's wake, historians and museum professionals tried to determine what the effects might be. "The full implications of the cancellation are still far from clear, but an interpretation deeply disturbing to historians and museum professionals had begun to emerge," the historian Richard Korn penned in a lament. "One of the premier cultural institutions of the United States, its foremost museum system, surrendered its scholarly independence and a significant amount of its authority in American intellectual life to accommodate a political perspective."[38]

"Is it possible, in our society," pondered the historian Neil Harris, "for museums deliberately to avoid all controversy in their choice of exhibitions?"[39] Even if such an imagined avoidance of controversy were possible, Harris and other scholars argued that such an outcome would poorly serve the American people. "Since their inception, many things about museums have been subject to angry debate; their systems of government, hours of opening and accessibility, sources of income, and patterns of patronage," Harris added. "But extended disputes about subject boundaries, public functions, and exhibition proprieties seem new." Harris concluded that museums needed to change: "Today's museums . . . are no longer accepted simply as custodians of truth; they are called upon to perform a wider range of social functions, and few escape extensive public subsidy. Our very notion of museum truth is now questioned."[40] Although older museums had

now occupied some buildings for well over a century, they had changed in the past, responding dynamically in some cases, to crisis moments. What was to lie ahead, however, was still unclear. Joining older museums in taking new approaches were many newer museums, some aiming to upend traditional museological approaches in favor of new methods and challenging exhibitions. Scholars, too, were thinking about and debating museums in new ways.

Conversation about the overall purpose of contemporary museums was also undergoing an important shift. By 1993, the US Holocaust Memorial Museum opened to the public, and the Smithsonian's new National Museum of the American Indian (NMAI) had been approved for construction, opening in September 2004. A proposal to build a new museum on the National Mall for the National Museum of African American History and Culture (NMAAHC) had been rejected. An authorization to build the museum was finally approved in 2003. In September 2016, the museum opened to the public. If museums had shied away from controversial exhibitions and subjects for a time in the 1990s, as so many historians feared would happen in the wake of the *Enola Gay* controversy, by the new millennium things were moving in a new direction. These new museums directly confronted subjects related to the history of enslavement, genocide, systemic repression, and the Holocaust.

The crises that many people imagined as starting to befall museums in the 1990s—storerooms being emptied by changes in the law and exhibits curated by the PC police—never truly materialized, as some people believed they

would. "Why have we recently become so consumed by the problem [of controversy in museums]?" asked Harris from his perspective as a historian in 1995.[41] It was not as though museums had not encountered controversy or challenges before, but suddenly the popular and scholarly fixation on large-scale museum controversy became foregrounded in an unprecedented manner. The answer to Harris's question is partly because the moment uniquely reflected the temporary cojoining of both lingering museum-based debates and broader cultural controversies.

What might we better understand by revisiting these histories? I argue that museums were again faced with a series of choices as they confronted new challenges. When these challenges are considered not just as episodes in isolation but as part of a longer trajectory of debates about museum and crisis, certain tendencies begin to stand out. Those museums that leaned into these challenges, opening up room for expanded dialogue and discussion, emerged stronger and healthier over time. Collections had been returned home and negative stories were written about museums in major magazines and newspapers, but museums and those who were thinking about them were forced through these events to more deeply consider their role in society. If the museum were to survive as an institution or an idea, it would need to respond to these tests and seek ways to thoughtfully take on difficult subjects rather than reacting to challenges more defensively.

By the mid- to late 1990s, it was clear that museums were entering a great era of change. This change was met by in-

tensive media scrutiny and popular talk about museums and their role in modern society. In spite of all of the anxieties expressed about the possible changes lying ahead, museums had, in the process of becoming more contested, taken up a renewed significance on the US social and cultural landscape. Both the Holocaust Museum and the Smithsonian's new National Museum of the American Indian were being constructed on the National Mall in Washington, DC. While this appeared to represent a victory for a growing discourse about different versions of the American experience, other people were less convinced. The museum curator Fath Davis Ruffins offered her perspective in the *Radical History Review*: "All museums reify notions about the past and are generally seen by their publics as embodying an authentic past, presenting validating versions of cultural sensibilities and artistic expressions, and serving as a fitting repository or memorial of the national mythos."[42] Is it even possible, then, to truly disentangle the "political" from historical interpretation? Is not the ownership, display, and interpretation of historical, artistic, or scientific material in a museum setting an inherently political act? Certainly, the decisions to dial back exhibitions or repatriate material from museum collections cannot be logically divorced from politics.

Some writers still worry that the growing calls for international repatriation will eventually lead to a hollowing out of major museum collections. It is also argued by some that the *Enola Gay* episode led to a chilling effect on efforts to tell more holistic, challenging, or critical stories that are less celebratory in their rendition of US history than more conser-

vative visitors desire to experience. Other writers challenge that the lesson offered by the era is that museums must not shy away from controversy but rather work to clarify their goals and objectives heading into potentially difficult situations.[43] These different, perhaps dueling, tendencies seem to pull museums in opposite directions.

The reduction of complex social issues into opposing sides of an ongoing and divisive "culture war" worked to constrain US politics in important ways. Some of the many effects of this strained discourse would only become clear decades later, but for museums, the impression was forceful and immediate. Arguments became mired in misinformation and heated emotion, limiting possible solutions as they related to cultural institutions.

By the late 1990s, however, some of the intense scrutiny placed on museums, including many of the doomsday predictions offered by media pundits and scientists writing about cultural institutions in the early 1990s, had waned. In the place of this breathless crisis rhetoric was the real work left to museum professionals and, just as importantly, the Native American delegations, outside advisers, and others working to make museums better. In the museum community, debates about deaccessioning, or selling or otherwise removing an object from a collection, were becoming harder pressed during the same era (a subject explored in more depth in chapter 6).[44]

Underneath it all, there remained some question about what exactly was broken about museums to begin with. Beyond the hotly contested moments explored with great in-

tensity by journalists and later historians, the available data seemed to suggest other realities. Starting in 1993, a program called Art around the Corner brought local schoolchildren to the Smithsonian's National Gallery of Art. The program then surveyed the children for several years following their visit. The surveys suggested that children who had been brought to the museum experienced heightened positive attitudes about art museums and art more generally, even years after they visited the galleries.[45]

During the year 1989, 24 million people were estimated to have visited the Smithsonian Institution. By 2000, this number had jumped to more than 31 million.[46] "I'm afraid we are going to have to win a lot of people back," worried the Smithsonian's spokesperson after controversies of the 1980s and 1990s.[47] In truth, they never really left. Controversial decisions about repatriation to Native communities or critical exhibits, in other words, had hardly killed the museum. Evidence instead suggests that museums became stronger and more relevant following the controversies.

In 2019, when another 22 million visitors walked through the halls of the Smithsonian, 2.8 million had entered the National Air and Space Museum, while 4.2 million wandered the halls of the National Museum of Natural History.[48] Controversies that were so predominant in talk about museums in the late 1980s and early 1990s again seemed like a distant memory. In this case, the ability to survive and even thrive in the newly altered environment depended on an ability to wrestle with central questions about museums and their core missions. Should museums exist to celebrate cultural heritage

or tell difficult histories? In light of the fraught history behind museum collections, how should we think about them in the present day? Who gets to hold the balance of power when making these important decisions?

The purported controversies surrounding museums were, except for threats to federal funds, rarely as critical as they were frequently cast. To a large extent, much of the controversy centered on the Smithsonian, a national institution used as an imperfect platform and stage to debate public institutions, education, and national heritage more generally during the late twentieth century. Many smaller museums were left behind in the popular debate about the purpose of museums in this era, though new laws and shifting ideas significantly influenced their futures. Rather than an era witnessing a dire hollowing out of museums in real terms and with regard to what they represented, museums instead maintained a level of cultural relevance that they might not have held otherwise through their centrality in ongoing cultural debates. With the twenty-first century on the horizon, distinctive and again unforeseen challenges were awaiting museums and the people who care about them.

Museum Crisis in Recent History

At present, two key challenges have created a new crisis moment for museums in the United States. The first is a long-overdue reckoning related to the realities of racism so deeply enmeshed into the national fabric. An estimated fifteen to twenty-six million people took to the streets following the gruesome police killing of George Floyd during an attempted arrest in Minneapolis, Minnesota, on May 25, 2020. In a wave of national protest and conversation taking place in the weeks and months to follow, museums and historical monuments in the United States and Europe were once again placed under greater scrutiny in regard to their many connections to various forms of systemic racism. In this moment, a truth almost hinted at throughout museum history became plain: museums can never be isolated from broader social conversations. Monuments across the country also came under greater scrutiny following recent events, in some cases altered by protesters wishing to draw attention to the inequity on display.

The second major challenge facing museums currently is the deadly and isolating Covid-19 pandemic that has been ravaging the planet.[1] This virus struck museums in ways that are as yet still impossible to fully comprehend but has most visibly resulted in shutdowns, cutbacks, staff furloughs, and

financial distress. We know that 98 percent of museums, historic sites, and other cultural institutions closed their buildings to visitors at some point during the pandemic and that more than half of museums furloughed or laid off staff.[2] Other staffers were pressed to continue their work remotely. If past crises are to be a model, it will take museums years to recover from the damage caused in 2020 alone.

In the book *Making Museums Matter*, author Stephen E. Weil argues that good museums hold two attributes: "a clear and worthwhile purpose and the resources needed to achieve that purpose." He elaborates, "The things that make a museum good are its purpose to make a positive difference in the quality of people's lives, its command of resources adequate to that purpose, and its possession of a leadership determined to ensure that those resources are being directed and effectively used to that end."[3] As this book has described, many institutions across the United States achieved some success in attaining these goals during the twentieth century, despite facing a wide range of crises. Museums were ascending to new heights, but treacherous new challenges were laying ahead early in the twenty-first century.

September 11, 2001, and Museums

On a crisp fall morning in 2001, a set of coordinated terrorist attacks struck New York and Washington, DC. Hijackers took over four airplanes and crashed three of them into landmark buildings, killing thousands of people while millions watched the events unfold. The incident triggered a global

economic turndown in the weeks and months to follow.[4] Many museums were closed almost immediately, part of a heightened state of alert when another violent event was anticipated to follow.[5]

"America's cultural life came to a standstill yesterday," reported the *Washington Post* the following day.[6] Many historic sites, monuments, and museums were temporarily closed.[7] The Smithsonian began to reopen as soon as the following day, while others opened more gradually soon thereafter. The conversation around museum security shifted in response to the attacks.

When museums did open the next day, many people already seemed to have a new relationship with them. In New York at the Met, curator Sabine Rewald spoke about an exhibition on the German painter Caspar David Friedrich titled *Moonwatchers*, remembering, "The show opened on September 11, 2001, strangely enough. The public didn't come, because we closed the galleries half an hour after the Museum opened on that extraordinary day. But this exhibition, with these very moving, meditative pictures, became a favorite with the public, because the public was in need of consolation, and people streamed to it and felt solace."[8] The Smithsonian and other federal buildings were given clearance to begin opening just one day after shutting down on September 11. Some museums looked to colleagues in Oklahoma City, who had reopened cultural institutions shortly after a domestic terrorist attack killed 168 people in the Alfred P. Murrah Federal Building in 1995. Museums were thought to provide an escape for a city and nation in mourning.[9] The

conversation about the utility of museums as a space for escapism echoed earlier conversations about museums in the United States taking place during World War II.

Museum attendance in New York City was the hardest hit after 9/11. Some smaller museums near Ground Zero in Lower Manhattan, namely, the Police Museum and the Museum of American Finance, were forced to move following the destruction.[10] In the wake of the incident, between both the sharp decline in tourism and the loss of an estimated 110,000 New York City jobs, many fewer people purchased museum tickets. Between September 2001 and October 2001, the combined attendance to the Metropolitan Museum of Art, MoMA, and Bronx Zoo was down 47 percent as compared to the same months the previous year.[11]

The attacks led to heightened fears about terrorism and added security measures to many museums. Visits to the Smithsonian declined from 31.7 million in 2001 to 26.3 million in 2002. Attendance would not reach near pre-9/11 numbers again until 2009, when visits finally jumped back up to 30 million.[12] Museums continue to consult with the Department of Homeland Security, which offers resources to protect museums, or what the agency describes as "soft targets." Museums, it argues, represent relatively open, crowded, public-oriented institutions and are left vulnerable to unsophisticated attacks.[13] Internationally, terrorism motivated a 2015 attack on the Bardo National Museum in Tunisia, a mass shooting and hostage-taking event that resulted in the death of more than two dozen people. In 2017, a man was shot as he attacked a group of French soldiers guarding an entrance

to the Louvre Museum in Paris. The attacker survived and later told investigators that he had planned to deface the museum's artwork with the spray paint that he was carrying in his backpack.[14]

Terrorism, however, was not the only threat to museums in the United States. Climate change, and its resulting connections to worsening storms, was about to become an increasingly important reality facing the United States and its cultural institutions in the new millennium.

Flood

In late summer 2005, one of the most destructive hurricanes in US history struck the Gulf Coast. The hurricane and flooding to follow killed an estimated 1,833 people. The storm, known as Hurricane Katrina, was a Category 5 cyclone, currently tied as having been the costliest storm in US history with regard to the total estimated value of property destruction caused by the event.

In September 2005, the *New York Times* reported that the New Orleans Museum of Art was under "lock and guard." The newspaper read, "It's a jarring sight: Two burly men carrying M-16 assault rifles on the marble steps of the New Orleans Museum of Art." The reporter summarized the situation: "The museum withstood the fury of Hurricane Katrina, suffering little damage and no looting."[15] Eight museum staffers—engineers, security guards, building maintenance workers, and an administrative assistant—stayed behind. They were joined by about thirty family members

also taking refuge in the museum as the hurricane approached. Some items were taken out of the galleries and carefully carted to storage areas, where they were placed on wooden blocks to prevent damage from possible flooding. Indeed, some flooding had occurred, as had a temporary loss of climate control, yet staffers were relieved to find that only one of the fifty sculptures in the sculpture garden had been smashed by high winds.

As the floodwaters in the city began receding, it was clear that the immediate threat to human life was presenting itself with more urgency than the damage happening to the museum's collection. By early September, the National Guard ordered the people in the museum to leave, and busses took them from the city. The museum's French insurance company hired a security team to send armed guards to investigate the situation, but when they arrived on motorboats (joined by the museum's deputy director), the situation they found was dangerous yet not completely devastating. The collection had escaped the event largely unscathed. National Guardsmen were already clearing the debris. Museum leaders had initially contemplated trying to evacuate the collection, perhaps to a nearby museum in Arkansas, but it decided to keep the objects in New Orleans.[16]

Without climate control for two weeks, the museum brought in dehumidifiers to help partly restore proper conditions for the artwork. "It was a good feeling to see that we dodged the bullet and that the collection was hanging on the walls just as we left it," said curator William Fagaly.[17] Museum staff predicted, perhaps with a wistful tone, that cul-

tural institutions would be key for the city in taking pride in its unique identity while it rebuilt: "That the museum can even contemplate reopening is a testament to the dedication of its staff," read the *New York Times* about the New Orleans Museum of Art not long after the hurricane.[18]

Another major hurricane again put natural disasters into the forefront of the conversation about museums, this time in October 2012, as Sandy, the deadliest hurricane of the year, caused extensive flooding and damage across much of the Northeast. The flooding in New York City and especially in Lower Manhattan ultimately proved to be some of the most destructive the city had ever experienced, causing massive amounts of damage and at least 233 fatalities. Widespread power outages, shuttered transit lines, and high winds compounded the problems. The new 9/11 Memorial and Museum in Lower Manhattan, still under construction, was flooded with twenty-two million gallons of water.[19]

After Hurricane Sandy, one million documents needed to be temporarily moved from Ellis Island, the nation's best-known historic immigration center, located in New York Harbor. The National Park Service sent the documents to a holding center in Maryland. Overall, the storm caused $77 million of damage to the island.[20] The museum at Ellis Island did not reopen to visitors for another year. The city's South Street Seaport Museum also shuttered, requiring major grant funding and more than four years to clean up flood damage and recover from the disaster. When the museum reopened officially, the Seaport Museum greeted its public in the neighborhood with an exhibition reflecting on

its community's history, *Street of Ships: The Port and Its People*.[21] The 9/11 Memorial and Museum sealed many exhibit spaces to prevent flooding and equipped the museum with pumps to quickly remove water.[22] Thinking ahead, quick action, and critical emergency funding had enabled museums and historic sites in New York to recover more fully than they otherwise might have.

In the destructive hurricane's wake, several important lessons were learned. Lessons about building security and safety were applied to the design and construction of the Whitney Museum of Art as it completed a new building in 2015. Other realities, including the need for small power supplies to be placed throughout museum buildings to allow staffers to keep their phone charged in an emergency, were made clear by experiences during the destructive storm surge and after.[23]

In response to the evolving crisis, several other large museums stepped forward to provide resources for other cultural institutions as they faced challenges in conservation and preservation. The Smithsonian's Cultural Rescue Initiative offered pro bono conservation assistance to several cultural organizations that suffered damage from the flooding. MoMA's blog began featuring stories with conservators who were providing care for water-damaged collections, an unfortunately common challenge facing museums in the wake of a hurricane or flood.[24] To deal with the unprecedented challenges on the horizon as a result of global climate change, cultural institutions and museum professionals would need to turn to each other to share expertise.

Museums and the Great Recession

Already by October 2008, executives at MoMA in New York were reported to be worried about the general economic outlook. "We know there's a storm at sea and we know it's going to hit land and it could get ugly," said the museum's director. Many museums slashed their operating budgets. Large museums were hit by the declining value of endowment funds, reduced giving, and somewhat slowed attendance. "Caution is the word of the moment," said MoMA's director.[25] Museums scaled back immediately in response to the worry.

Art museums scrambled to find private donors to support the loan-dependent blockbuster exhibitions they hoped to continue to display.[26] By 2009, the Met closed twenty-three satellite shops spread out from New York to California. The museum also implemented a hiring freeze. Visitor numbers, paid memberships, and the museum's endowment were all down, leading to changes in the overall budget. "[The Met] is also in the process," the *New York Times* reported, "of a museum-wide assessment of its expenses to see how it can further reduce costs."[27] Belt-tightening was happening all over the museum landscape.

As the economy worsened, some museums sought to part with or sell collections to save costs and raise funds. "Sometimes museums get in trouble. Deep trouble," explained one National Public Radio (NPR) report. "Not because they damage art, or let it get stolen . . . but because they sell it."[28] Museums have historically used the word "accession" to describe their collections acquisitions. The term "deaccession," there-

fore, came to describe moments when museums remove objects from their permanent collection, often with the intent of selling them.[29] Professional organizations have encouraged museums to use the funds from sales to care for collections or to add new collections into the fold. They can also freely deaccession material later discovered to be forgeries or fakes. The money is not supposed to be used for general operating costs or as a Band-Aid to cover up for poor financial planning.

When the Delaware Art Museum attempted to pay off a $19.8 million debt by selling a painting at auction, the action received the museum community's scorn for not having followed established guidelines.[30] After the National Academy Museum in New York City sold two masterworks to fund museum operations, it was officially censured by the Association of Art Museum Directors.[31] Some museums, it seemed, were desperate enough to ensure their survival through these sales, even if it meant dealing with the penalties involved.

These financial and ethical issues were felt most acutely at the Detroit Institute of Arts (DIA) following the crash.[32] Economic downturns in the late twentieth century had squeezed the museum before, forcing shutdowns and economic strain with state and city governments, but the city of Detroit was hit especially hard by the 2008 recession. When it became clear that the city was heading toward filing for Chapter 9 bankruptcy, the largest such municipal bankruptcy filing in US history, many observers worried that creditors would come for the DIA's valuable art, estimated to be worth more than $16 billion on the open market. It was shaping up to be an absolute calamity.

During the twentieth century, as Detroit became a wealthy industrial powerhouse, the city established one of North America's most important public art collections. The DIA's galleries show a wealth of art from around the world, drawing from a collection of sixty-five thousand paintings, sculptures, and other objects. The exhibits introduce many visitors to a wide range of important American artists, breathtaking and rare examples of grand murals painted by the Mexican artist Diego Rivera, and spectacular midcentury pop-art prints. Fortunately, a court ruling spared the DIA's artwork from sale.[33] The museum successfully converted its status into an independent nonprofit, separating its fortunes from the municipal budget.

The city of Detroit ultimately managed to restructure or repay many debts as the municipal budget improved with the somewhat recovered health of the automobile industry. Community, regional, and national financial realities again struck museums with great force. The crisis was in this respect national as well as regional and local. The depth and nature of the challenges facing cultural institutions depended in many respects on the overall health of the surrounding communities.

To survive, museums need to show the ability to deftly evolve and meet challenges. Sometimes this means changing the nature of a collection as community and scholarly needs shift. Before World War II, it was much more common for museums to swap or trade items of equal value to improve their collections. After the war, loans gradually became the preferred mechanism for addressing "gaps" in museum

collections.[34] But the problem of how to trim the collection remained because museums cannot simply grow their collections unabated indefinitely. In 2014, NPR described "deaccessioning" as a "dirty word" in the art world.[35] This is an unfortunate popular perception, as deaccessioning should be viewed as a healthy component of museum life, similar to how a healthy tree needs to be trimmed back occasionally. Likewise, communities need to be able to provide input about what the museum prioritizes. Furthermore, museum leaders need to stop making the mistake of only turning to high-profile deaccession actions as a lifeline in bad economic times, making the action seem like a cash grab.[36] Instead, thoughtful changes to museum collections should be made with planning and intent, following a process of best practices as laid out by AAM and AAMD and as followed by other peer institutions.

To work most effectively, the planning process for these crises needs to be committedly countercyclical. In other words, planning for the next financial downturn should be taking place when economic times are good. When things are safe and stable, museums should discuss plans for fire, flood, and other sorts of potential threats to visitors, staff, collections, and building safety. Deaccessioning should take place regularly and with clear intent, rather than as a frenzied act to pay some overdue bills. Museums and their leaders must plan ahead, as difficult as it may be, for the challenges that lie around the corner.

On September 11, 2011, ten years after the shocking attacks had taken place, a new 9/11 Memorial and Museum opened

in New York City. In 2011, a brief entry on the *Artforum* web-
site noted that while attendance at MoMA was down 11 per-
cent, the Met hit a record 5.6 million attendance figure. The
Met cut its staff by 14 percent as a result of the 2008–2009
recession, but membership income was up 7 percent.[37] Mu-
seums had largely recovered and responded to the events of
9/11, but the recession to follow suggested that museums were
hardly in the clear.

While museums anticipated new challenges in fundrais-
ing, technology, and connecting with younger audiences,
other fires were smoldering, with crackling embers ready to
grow into destructive flames.

Fire

Following the Civil War–era fire at the Smithsonian Insti-
tution, museum builders became more aware of potential
dangers related to fire hazards. They began constructing
museums, and other public buildings, out of different mate-
rials, rethought architectural approaches, and foregrounded
safety more generally.[38] These efforts included museum
architects, who were often keen to construct fireproof build-
ings that suited changing architectural tastes. Classically
inspired buildings grandly constructed out of marble gave
way to sleeker-looking modernist buildings in the later twen-
tieth century. Despite museums' best efforts, however, they
still had to contend with the threat of fire. In both the United
States and globally, many older museum buildings suffered
from decay and neglect. In September 2018, more than 90

percent of the collections held by the National Museum of Brazil in Rio de Janeiro were destroyed when most of the museum's main building was incinerated in a massive blaze.[39]

In October 2019, an accidental fire in Southern California was sparked when high winds caused a downed tree to hit a power line, igniting a blaze that eventually consumed hundreds of acres. The incident killed several California residents and caused power companies to temporarily shut off power to hundreds of thousands of people. Many people were forced to evacuate. The fire started near the spectacular J. Paul Getty Museum of Art, but the blaze then raced toward other cultural institutions as it consumed homes, businesses, and vast sections of the landscape. Wildfires of this kind are becoming more common and intense following changes to the climate and built environment.

"The fire came dangerously close to the Ronald Reagan Presidential Library," read newspaper reports, "but was saved by a shift in the winds—and the work of goats brought in every year to create a firebreak by chewing through vegetation surrounding the complex. About 1,000 firefighters also battled the blaze on the ground while helicopters and airplanes attacked with water drops from above."[40] The Getty and Reagan Library were shuttered temporarily as firefighters worked to battle the blaze.

At the Getty, about fifty staff in the museum's security, grounds, custodial, and facilities departments helped assist fire crews and manage the museum's fire support system. The Getty also served as a temporary rest area for fire crews as they fought the wildfire and worked to protect human life

and property. The Getty had faced fires before, as recently as late 2017, but none had come as close as this now seriously threatening blaze. Mercifully, the disaster spared the museum, thanks in large part to the efforts of firefighters, museum staffers, and even the brush-clearing goats. Together, they had beaten back the flames and saved the Getty Museum and the Reagan Library.

By early November 2019, the Getty announced that its museum and villa were reopening to the public. "The dedication of our staff and the professionalism of our region's first responders has been nothing short of heroic," stated Getty Museum president Jim Cuno. "We are deeply grateful for their courage and hard work," he added.[41]

Only a few weeks later, on January 24, 2020, a fire across the country in New York City brought destruction to a facility housing collections for the Museum of Chinese in America. Initially, museum staffers feared that the collection would be entirely destroyed, by the fire itself, corresponding smoke damage, or the water used to tamp down the flames. Nine firefighters were injured battling the massive five-alarm fire. Many observers feared that the museum's eighty-five-thousand-object collection was gone forever. The collection held rare and priceless examples of material history speaking to the story of the Chinese American experience. Scholars and community members considered it one of the most important collections of its kind in North America, including wedding dresses, artworks, photographs, musical instruments, examples of immigration papers, restaurant signs, menus, textiles, and many other objects.[42]

Fortunately, while much of the museum facility's roof had been burned and the building remained endangered, significant portions of the collection were spared. Museum staff worried that the lack of structural integrity would put them in a position where they would be unable to access the building for months. Early in 2020, the museum still feared the collection to be largely lost or permanently damaged. "There was a groundswell of mourning. . . . It was like 350 family legacies died," said Nancy Yao Maasbach, the museum's president. Fortunately, on March 8, about twenty workers wearing protective gear carefully removed about two thousand boxes of material from the partially destroyed collections building. As they passed the boxes from one person to the next, it became clear that much of the museum's collection had been spared.[43]

In this case, the museum responded to the crisis with rapidity.[44] Crews were on-site as soon as possible to assess the damage and to start the cleanup. Tragic though the fire may be, with the widespread media coverage attracting attention to the museum and the catastrophic loss of historical collections, the museum took immediate steps to begin raising funds toward recovery, conservation, and repair. The institution's crowdsourced fundraising campaign brought in thousands of dollars to the organization.[45] Fortunately, the damage to the museum's collection was much less than originally feared. The fire nevertheless proved destructive; the museum still desperately needed the support to rebuild, and unknown to most anyone at the time, a global pandemic was about to fundamentally alter museum history.

Covid-19

Covid-19, the respiratory disease caused by the novel coronavirus, sprinted around the world in late 2019, throughout 2020, and into 2021. The resulting illness killed millions worldwide and, as of this writing, more than 620,000 in the United States. The pandemic shut down much of the global economy and led to a rolling public health crisis in many places around the world. To date, the virus has killed more people in the United States than US battlefield deaths experienced in World War I, World War II, and the Vietnam War combined. Thousands of museums in the United States and globally were included in the indefinite shutdown due to changing state and local regulations regarding public gathering spaces as well as general public health concern. With hundreds of communities across the United States ordered shut, museums suddenly lost basically all revenue from ticket sales, gift shop receipts, and café tabs. The health crisis quickly became a worrying economic crisis for museums and the millions of people working hard to make a living at cultural institutions.

Following an intense debate about closure and plans to implement the lockdown, about 90 percent of museum buildings around the world were closed to visitors as a result of the pandemic. UNESCO further estimated that about 13 percent of museums were in danger of permanent closure.[46] By the spring months of 2020, the lockdown was in place. Most museums, however, did not simply sit idle.

Almost immediately, a turn toward expanding digital access grew during the lockdown.[47] Numerous museums, with their physical spaces closed, pushed existing digital resources and hoped to expand further into online spaces, a difficult challenge to execute remotely when so many staff had been recently furloughed. The Smithsonian, for example, encouraged potential visitors to engage with its newly available Smithsonian Open Access Portal, which allows users to download millions of 2-D and 3-D object images for their own use.[48] Other museums promoted new and expanded online platforms and sought to engage with audiences on social media and in other digital outlets. Behind the scenes, museum staffers worked remotely or cautiously began working to refurbish museum buildings, absent of the typical crowds that often make renovations challenging.[49]

By early summer in 2020, many museums warily considered reopening. Some experts anticipated that the public health situation could rapidly deteriorate with the reopening of state economies more generally. The Smithsonian organized a special task force to prepare for reopening.[50] Curators imagined that museums would reduce the number of large traveling exhibitions in favor of shows drawing more from permanent collections. Questions and uncertainty loomed large.

Museums quickly began to consider new protocols for social distancing in exhibition halls, face mask requirements, and cleaning high-touch surfaces in museums (such as heavily used elevator buttons). Even still, a troubling rise in infection rates appeared across the nation just as places were

beginning to reopen, leading to worries about a possible second prolonged shutdown.

For a time, formerly crowded exhibition halls were largely empty. Some museums and other cultural institutions looked to creative efforts to attract online viewers during closures. "The COVID quarantine has caused everyone to go a little stir crazy," read one museum website, "even the residents of the Kansas City Zoo." The website continued, "So several of the penguins decided to go on a field trip to the Nelson-Atkins, which is still closed, to get a little culture."[51] When viewers click on the video clip, an exterior shot of the grand museum building is followed by a shot of the museum's marble-lined lobby, occupied now by three black-and-white penguins. "We are so happy to today welcome our colleagues from the zoo, and they brought special friends. And today we are seeing how they are reacting to art," explains the museum's executive director, Julián Zugazagoitia. Penguins and other zoo animals, explains the zoo's director, Randy Wisthoff, can get bored, especially with less stimulation during the shutdown. The zoo is always looking for new ways to mentally stimulate the animals, Wisthoff explains. The added media attention during the quiet shutdown weeks was surely viewed as a positive too. In the video, three penguins march through the exhibition halls as though they are little tuxedoed tourists, gawking up at the astonishing art hanging high above their tiny heads. As of this writing, the short clip on YouTube has garnered more three hundred thousand views.[52] New digital outlets and attempts to fill the void during a prolonged shutdown could not entirely gloss over the fact that so many mu-

seum professionals lost their jobs or needed to make major adjustments in their lives during the lockdown. A present museum crisis in this regard is as yet still ongoing.

In 2020, the Association of Art Museum Directors (AAMD) relaxed the protocol on deaccessioning art, making space for museums to sell certain collections to pay for collections care in the next two years.[53] The Brooklyn Museum soon put twelve works up for auction at Christie's Auction Company. "This is something that is hard for us to do," the museum's director, Anne Pasternak, was quoted as saying in media reports following the announcement. "But it's the best thing for the institution and the longevity and care of the collections."[54] The Metropolitan Museum of Art, too, having laid off eighty-one employees during the pandemic, considered selling artwork to cover operational expenses as it faced a $150 million shortfall. The museum's director, Max Hollein, told National Public Radio in 2021 that the museum was not quite facing "an existential crisis" but that "attendance is of course, way, way below where [it was] before the pandemic." This reality had resulted in a new budgetary situation, pushing the museum to slow its acquisitions programs while considering possible sales from the collection. "We continue to grow," Hollein said; "we just for this two-year period might not grow as vigorously or as rapidly as before."[55]

As was true in 2008–2009, museums are presently reconsidering the trajectory of their upcoming exhibition plans. Large art museums have in many cases become reliant on major blockbuster exhibitions to draw crowds. The displays

were often rich with loans from other museums, complex and expensive to coordinate, but thought to be worth it when they grabbed attention and brought in crowds. Perhaps more significantly, societal conversations were shifting dramatically. More attention was being paid to racism, colonialism, and legacies of inequity in museums settings. Although the challenges calling for museums to do more in these areas had existed for some time, they were about to experience renewed primacy.

Race and Museums Revisited

In 1967, just one year before the violent deaths of Martin Luther King Jr. and Robert F. Kennedy Jr., the Anacostia Community Museum opened in Washington, DC. The Anacostia Museum was created with the hopes of bringing the Smithsonian Institution, with its predominance on the National Mall in downtown Washington, DC, to the historically African American Anacostia neighborhood just a few miles away. The museum was thought to represent the culmination of earlier efforts to showcase Black history and culture in museum settings.[56] Notably, these stories were traditionally given much less space or attention in museums of history, art, and culture in the United States. Protesters in this era called museums to task for celebrating narratives of colonialism and Euro-American-bound visions of progress while marginalizing the histories of women and minorities. By 1970, the Anacostia Museum had become permanent, and its operations were added to the federal budget. Still, Black

voices were mostly absent from museum spaces around the country and the world.

In a 1991 work, installed at the Worcester Art Museum, the artist Renée Green confronted themes related to racism and repression in US history, adding quotes on whiteness and Blackness by Herman Melville and W. E. B. Du Bois to a dramatic, stage-like installation. The work reframed the entire gallery spaces around the critical examination of the racialized narratives present in the museum experience.[57] Prominent African American artists were bringing attention to racial inequities and erasure in these same museum spaces. The work demonstrated great potential to open up important conversations.

Fred Wilson is an artist of African American, European American, and American Indian descent. As an artist, Wilson found museums to be a productive site for his path-breaking conceptual artwork. In 1992, Wilson attracted attention following the installation of his work *Mining the Museum* at the Maryland Historical Society. The installation called attention to issues surrounding representation (and lack thereof) of Black voices at the museum. In one piece, Wilson shined a bright light directly onto the darkened image of an African American child, pushed to a lower corner in a long-exhibited painting. Employing a largely forgotten object from museum storage, Wilson used a whipping post from the Baltimore city jail to tell a larger story about racism, inequality, and brutality.[58] The landmark exhibition encouraged museums to look more deeply at their own collection and seek out collaborations with artists, even when, perhaps especially when, these

same artists challenge both the institution and audience with difficult questions and realizations.

Starting in summer 2013, the organized movement known as Black Lives Matter (BLM) emerged on the national scene. BLM raised awareness about the widespread problem of police brutality across the country and drew attention to problematic mass incarceration, Black women's lack of access to health care, and Black voter suppression. At about the same time, a permanent museum recognizing the many contributions of African Americans to US society was finally being built on the National Mall. The museum sought to finally address the absences in communities such as Anacostia and the work of artists like Green and Wilson who had pointed to the ways in which most traditional museums glossed over, or completely ignored, Black history and culture.

Construction began on the Smithsonian's National Museum of African American History and Culture (NMAAHC) in 2012, and President Barack Obama delivered an address in September 2016 at the museum's opening ceremony. The museum prominently brought stories of enslavement, emancipation, change, family life, protest, and much more to the national museum. President Obama stated, "The best history helps us recognize the mistakes that we've made and the dark corners of the human spirit that we need to guard against. And yes, a clear-eyed view of history can make us uncomfortable, and shake us out of familiar narratives." He added, "But it is precisely because of that discomfort that we learn and grow and harness our collective power to make the nation more perfect."[59]

In 2014, following the tragic police shooting of eighteen-year-old Michael Brown in Ferguson, Missouri, an expanded conversation about race and police brutality was touched off in the United States. In the wake of the event and protests that followed, the museum activists LaTanya S. Autry and Mike Murawski launched a social media hashtag and promotional campaign called #MuseumsAreNotNeutral. The project seeks to expose museums as institutions that, while often presenting a posture of neutrality, are in fact subject to their own biased choices with regard to hiring and the relegation of resources.

In the 2018 blockbuster superhero movie *Black Panther*, the film's protagonist, T'Challa, is visiting a museum in London when a white curator greets him. "How can I help you?" asks the curator. "I'm just checking out these artifacts," T'Challa responds. When the curator begins explaining to him the history of objects that actually originate from his fictionalized African homeland, Wakanda, he corrects her on their origins. "How do you think your ancestors got these?" he asks the curator. "Do you think they paid a fair price? Or did they take it like they took everything else?" Security guards then attempt to remove him from the galleries. The movie prompted further discussion about race and the history and legacy of colonialism in museum collecting and presentation, with several popular or "viral" articles appearing on the subject online after the movie's release.[60]

Two years later, amid the Covid-19 pandemic, a remarkably ugly instance of police brutality again called widespread attention to the still unresolved matter of systemic racism and

the mistreatment of African Americans and other minority groups in the United States. On May 25, 2020, Minneapolis police officers were attempting to arrest forty-six-year-old George Floyd. While restraining Floyd with a choke hold for more than eight minutes, Floyd was asphyxiated and died. The shocking video of his murder brought about protest first in the Twin Cities and then in communities large and small across the United States and around the world. While the individual act was horrific, it represented a much larger crisis in US society.

In the wake of the Floyd tragedy and renewed attention brought on by impassioned worldwide protests, many museums moved to publicly recognize Juneteenth, a holiday acknowledging the end of slavery in the United States, for the first time. At about the same time, the American Museum of Natural History (AMNH) in New York announced plans to remove a hotly controversial statue depicting President Teddy Roosevelt on horseback with Native American and African American men at his side, portrayed as though in lower or subservient positions. The museum had recently made efforts to interpret through gallery and web exhibitions the racist depiction greeting visitors to the museum from its main, Central Park–facing entrance. The statue was first commissioned in 1925 and had met visitors to the museum since 1940. Even with efforts having been made to install new interpretive signage and a temporary exhibit addressing the problematic renderings offered in the historical work, the statue still seemed awkward and dated. The mythos of history and originality clouded the debate. The museum

building predated the sculpture by many decades. Roosevelt's connection to the museum was also much deeper than a tired sculpture might render. In recognition of this fact, the museum chose to rename its Hall of Biodiversity in Roosevelt's honor. Removing or altering the statue could hardly represent complete erasure, therefore, when a much larger and more complex legacy was left behind. In June 2020, the AMNH announced plans to permanently remove the statue from its front entrance. Conservative counterprotesters gathered later in the month in a futile effort to save the statue.

Between the 1960s and the present, new discussions emerged in sporadic waves, prompted by outside events and the voices of African American and Native American artists, writers, activists, and museum leaders.[61] A breakthrough exhibition, new museum, blockbuster film, or protest movement can provide an important spotlight to issues surrounding racial justice and museums, prompting a long overdue series of conversations about this ongoing crisis. More needs to be done, however, to improve representation in museum spaces in a sustained way, thereby offering a more honest portrait of the world to museum visitors.

Reinventing the Museum

Following recent upheavals, museums have struggled to find true north.[62] Calls to make museums more relevant should not be read as idealized hopes for the distant future, but rather, these increasingly vocal desires being expressed by so many people represent crucial paths forward for museum

survival, especially with one out of every ten institutions likely to close as a result of prolonged economic difficulty. Sustained resistance to needed changes being demanded by communities that support and surround museums will mean almost certain death for museums and other cultural institutions. Museums are also craving sustained support from local and national governments.

In President Obama's address at the Smithsonian's NMAAHC quoted earlier, he closed by stating that future generations will be able to visit the new museum as well as the many monuments around the National Mall: "And together, we'll learn about ourselves, as Americans—our sufferings, our delights, and our triumphs. And we'll walk away better for it, better because the better grasp of our history. We'll walk away that much more in love with this country, the only place on Earth where this story could have unfolded."[63]

As has been shown repeatedly throughout the history of museums, they and other cultural institutions can never fully disentangle themselves from their larger surroundings and the depths of their historical context. Crisis moments hitting the surrounding regions and communities were and are felt by museums across the nation. This can range from physical disasters to financial threats to social protests, to name just a few. Adding to the existing tensions was a deadly riot that took place contesting the outcome of the 2020 presidential election. Not only were Capitol Building rioters misled to violence by a delirious and dangerous president spouting false rhetoric in Donald Trump, but they caused damage to historic sites on the same National Mall where President

Obama had offered such an optimistic rendering of the nation's future just a few years earlier.

Museums continue to benefit from thoughtful and committed disaster-management planning. Surely, however, recent history offers lessons pointing not just to safeguarding museums as though they are preserved in ancient amber. Instead, we must protect museums and other cultural institutions while also constantly revisiting and reassessing their relevance to the needs of the community and larger world. In some instances, this will mean hosting difficult conversations, listening to jarring truths and opinions while simultaneously engaging in overdue transformations. Recent episodes of terrorism and other violence, experienced both domestically and internationally, have introduced new questions about museum safety.

Disasters and crises, however, are not just episodes that strike museums directly, as we have seen. Even the best crisis management, therefore, cannot fully prepare museums to take on the challenges around the corner. A crisis befalling a community may also push museums toward broader reflection, action, and ultimately, change. To understand the challenges that lie ahead, museums should both strive to better understand their histories and the challenges encountered in the past and also take a clear-eyed and honest assessment of the issues facing their communities. This includes working to better understand broader community histories of racism, discrimination, and relevant economic challenges. Once museums and other institutions better understand these histories, they can work to make more effective, sincere

steps forward to address them in collaboration with their surrounding communities. This should also include a broadening of the discussion about the need to diversify museum employment and leadership to make these positions more reflective of the communities they serve.

In response to lessons learned from earlier crises, museums and associated nonprofit organizations have begun to take a greater command of crisis-management planning, supported by major government granting agencies such as the National Endowment for the Humanities (NEH), the National Endowment for the Arts (NEA), and the Institute of Museum and Library Services (IMLS). Additionally, the Mellon Foundation has recently supplemented funding for these types of professional development experiences for museum staff. Some funding is also available for disaster-management planning on the state and local level. Nonprofit conservation organizations such as the Midwest Art Conservation Center (MACC), housed at the Minneapolis Institute of Arts in Minnesota, provide an array of disaster preparedness and response workshops for cultural organizations and museum professionals. Collectively, these disaster preparedness and response programs represent an important step forward for museums and other cultural institutions in the United States.

The nature of the reflection that museums undertake cannot merely be internal. For museums and other cultural institutions, it needs to respond to the needs of the community. Whereas museums have traditionally positioned themselves as the arbiters of truth and authority, recent turns have often been about exploring the possibilities inherent to the em-

brace of multiple perspectives and meaningful collaboration. Many public historians and other museum professionals have been diligently preparing to open up this dialogue over the past several decades.[64]

In New York and New Orleans, a reality that has proven true in different types of crisis situations might be distilled into the following: the best security asset that any museum has is its staff. The staff in many instances know and care deeply about the museum, sometimes going to great lengths to protect the collection. Museums should embrace this dedication while also making plans to ensure the safety of staff and their families in emergencies. Rather than exploiting the dedication of staff, museums should seek and find ways to ensure that they are fairly compensated for this passion, experience, and willingness to care for and improve the institutions they care about so much.

As the public health threat posed by Covid-19 dissipates some, museums look toward reopening. The world they reopen their doors to, however, has forever changed. By taking a brave and principled path forward and opening themselves up to critical conversations, museums and those who care about them can forge something truly important in response to the many challenges that still remain.

Conclusion

Revisiting the history of museums in crisis suggests several important and remarkable truths about cultural institutions and life in the United States. For one thing, while certain disasters befalling museums have been destructive, the museum as an idea and many museums as institutions have proven to be extraordinarily durable as cultural concepts. Even as contexts evolved and serious challenges are faced, audiences continue to be drawn to museums large and small across the country. Many individuals have been deeply committed to the museum idea and their particular institutions over the past century.

Museums have faced crises of different kinds: environmental, economic, political, social, and ethical problems. These challenges have often overlapped. While museums have anticipated some obstacles to come, the future has often proven impossible to predict. Even at the moment, museums have sometimes named some of their greatest challenges while being blind to others. As was asked in the opening pages of this book, how might it even be possible for museums to predict challenges that lie ahead or imagine the obstacles that they have not yet faced?[1]

Museum fires, hurricanes, and earthquakes are often more localized or regional as calamities. Global pandemics and

economic downturns have hit museums as a national or international collective, but the effects of these disasters were often understood institutionally, rather than through a wider lens of cultural and social events. In times of crisis, museums have often looked to one another for clues about how best to move forward. Yet even within the same city, each crisis has typically been handled in distinct ways by different institutions. This provides an opportunity to assess the choices made by museum leaders during challenging times, offering important, if at times confusing, historical object lessons for anyone thinking about museums today.

In studying the disasters befalling museums, it is tempting to celebrate their robust durability as institutions. In many difficult episodes, however, museums have had to scale back plans, for example, educational programs for children, that probably would have served society in important ways. Jobs have been lost in response to economic downturns. Physical threats of all kinds have been made manifest. Endless counterfactual questions and hypothetical scenarios are left in place: What if a better economy had allowed a museum to retain staffers and charge ahead with ambition? What if that fire had not destroyed those collections? Will public opinion as it relates to museums swing in a different direction? Had museum leaders hindered progress by not being more forthright about the challenges they faced?

In some respects, museums carried on, and as this book has argued, they were often better positioned through challenges for the improved times to follow. But it is also important to retain a sober remembrance of the many losses and

failures endured along the way. Museums have not always leaped into the changes they needed to move forward. They were sometimes dragged in the right direction by those who were willing to raise their voices and confront the status quo as it related to public institutions.

While many institutions have been fortunate enough to make it through times of severe crisis, people working for museums were often less fortunate. Staffers considered to be laborers or clerical workers, especially women and people of color, have often been the first to be let go in times of economic distress. This is true for many commercial enterprises and cultural institutions, but it stands out as notably apparent that museum curators and high-level administrators often keep their jobs in crisis moments while other museum workers are not so fortunate. In the face of this reality, history repeatedly demonstrates that museum staffers of all kinds prove crucial to the continued vitality of museums as institutions.

In crisis moments, the choice should not be people or institutions. This is a false dichotomy imposed on many discussions about crisis moments and cultural heritage by the tyranny of cynicism and low expectations. By framing situations through this problematic rendering, thinking about how best to confront challenges facing museums becomes stunted by unnecessarily forced limitations. The solution should instead be people *and* institutions. These institutions, however, must be constantly reimagined and reformed in light of both their histories and the present needs of their communities and those who are affected by them. Greater

transparency and attunement to the social happenings around them would serve them well in this context. Museums simply cannot afford to ignore the outside world, and in truth, they never really could do so at all. Cultural institutions also struggle at key moments when their leaders have failed to imagine how they might evolve to meet new and future challenges. The myth of the museum as unchanging needs to die for museums to survive into the future.

A review of crisis moments for museums suggests that some events, such as the 1918 flu pandemic, influenced museums somewhat less than one might have imagined. Other moments, like the perceived crisis of the "culture wars" of the 1990s, are thought to have had a much larger influence on the course of museum history. Reading museum annual reports, newspaper columns, and archival documents against the grain and with greater attunement to social context, however, suggests that museums are never actually as isolated as they are sometimes depicted. Global and regional happenings nudge (or jolt) cultural institutions in certain directions. We rarely comprehend these complex events accurately as they take place in real time. Rather than considering these stories as neatly packaged "lessons" for museums, reconsidering episodes of crisis in museum history should instead expand our collective thinking about how to possibly address current problems and better prepare for the future.

Museums must always be preparing for the next crisis, both predictable and unpredictable, just around the corner. For however much we might like to prevent such events, it is possible to foresee that museums in the future will again

be hit by ethical crisis as well as floods, fires, earthquakes, hurricanes, pandemics, and economic downturns. Making preparations to ensure an adequate response, making ready for broadly imagined crisis moments as yet unforeseeable—this is perhaps the truest and most essential challenge for museum leaders. Planning ahead for these crisis situations requires forethought and discipline. It also requires some imagination. Advanced planning also requires a commitment to the necessary work, which is not always as splashy as chasing after the next blockbuster exhibition or major acquisition.

A remarkably diverse array of factors came together to ensure that museums have lasted in some form in US society. Most importantly, in many cases, are the museum staffers who have ensured the safety of museum buildings and the integrity of cultural collections. But the staffers who deserve credit are not always the curators whose heroism in preserving collections is frequently valorized in the media. Security guards, custodians, and groundskeepers have stepped up to a remarkable degree to protect museums during crisis events. National Guard soldiers, firefighters, even hungry goats have all helped ensure the survival of threatened cultural institutions. New voices and more diversity in museum staffing can also serve to help remake museums in an important way, building them up to be more genuinely reflective of the communities they serve and leading to a wider array of solutions to existing and future problems.

The dilemmas so often perceived as most likely to be pressing for museums are not always the challenges that truly

become most crucial to address. Social and cultural change is largely unpredictable. Economic downturns are only predictable in the sense that we know they will most affect people in lower, more vulnerable, economic positions. Museums both large and small, too, are hit hard by economic recessions, though by resisting the temptations to introduce extreme austerity measures or through government assistance, museums have been able to reinvest, reinvent, and serve as important economic and intellectual engines. In pulling back on expensive exhibits and overextended commercial efforts, some larger museums have successfully reined in expenses.

Museums will never be fully disentangled from their complex histories. To move forward, those who are connected to museums should instead focus on moves to address past histories and create more inclusive futures. New professional standards in museums, conservation, and archives represent productive steps forward. A continued need still exists for historians and others to more broadly and in a more sustained manner engage with underrepresented voices in advancing museological practices. Crisis moments have seemed to underscore these needs in noticeable ways.

Whom should museums serve? What stories should museums tell? There is, of course, no single answer to these important questions, but museums should explore what it means, and what it has meant historically, to be human. They should also help us understand our planet, the environment we should be better stewards for, and our place in the universe. Museums should use stories to make us think. Attempting to serve the broadest number of people possible remains a

worthy goal, but this should not dilute efforts to challenge the public and enrich museum experiences through thoughtful displays rather than blockbusters intended mainly as crowd-pleasers. Although museums are deeply influenced by the ghosts of their past, they (at least in the United States) are today nevertheless capable of doing different kinds of new work with and for many communities. Museums often use narrative or storytelling to communicate ideas, sometimes more effectively than others. Objects are capable of speaking to or sustaining many different narratives. People continue to want to see rare and valuable "stuff" in person. The trick is figuring out, depending on the context and institutional aims, what stories a museum is best positioned to tell and how to do so effectively. Some communities might benefit most from facing difficult narratives head-on in certain contexts, while others may have a greater need for public spaces that focus on inspiring audiences by showcasing progress and achievement. Only relatively recently in museum history were institutions even starting to garner a more granular understanding of their audiences beyond the basic attendance numbers that museums began compiling in the nineteenth century.

We also may need to temper our expectations some. Museums are embedded in economic, social, and political forces that are both institutionally unique and similar to other cultural institutions. And while they are certainly capable of doing good work—and more and better work, for that matter—they nevertheless still face key limitations and challenges. These are shaped by the state or other political or so-

cial forces in addition to episodic disasters. Museums in the United States and many other places can make a social mark, but they cannot singularly solve the global climate-change crisis or fix widespread racial and economic inequality. The museum, in this way, must work alongside other truth-seeking institutions. When museums lack basic resources, they are fundamentally restricted in the types of actions they can take. In a fast-paced world with mountains of new ideas and ways to present them, a thirty- or forty-year-old exhibition on African or Pacific cultures feels excruciatingly dated. Sometimes, museums are written about as though they all have unlimited resources to enact fresh change when this is most often not the case in reality.

As a result of the media's growing significance in US life, museum crisis episodes in major coastal cities like New York and Washington, DC, have received outsized attention. On the other hand, the debates occurring at these prominent institutions have often prefigured and included national conversations about museums and their role in any given community. This book offers a start, but studying museums in crisis should push us to take an even wider view to learn much more.

Museums are not invincible. As this book has shown, museums have repeatedly cut or furloughed staff, putting people out of work at dire moments economically. Plans have been curtailed at key moments in world history. Some museums have even shuttered permanently. Others have sold off masterwork paintings to the highest bidder in a desperate effort to survive. To point to museums' durability as institu-

tions or the maintenance of heritage collections tells only part of the story.

As recently as 2012, museums in the United States were thought to employ four hundred thousand paid staff. They were estimated at that time to contribute $21 billion to the economy annually.[2] This alone makes a significant economic repercussion worth considering, and when economic times are reasonably good, museums remain as popular and culturally important as ever. In 2018, the Metropolitan Museum of Art set new attendance records when it hosted 7.35 million visitors from New York and around the world.[3]

Museums and their staff are wise to engage in ongoing disaster-preparedness training. Indeed, several museum-based nonprofits focusing on conservation offer low-cost training for museum professionals, but funding disaster-preparedness training of any kind often proves to be a smart investment. Disaster management and preparedness should also be on the minds of those who train upper management (who, frankly stated, have been in some cases ill suited for the challenges at hand) and those who are most responsible for the safety of the building and the direct protection of an institution's valuable resources. Disaster-preparedness training, in other words, should not be limited to curators, conservators, and collections managers but rather should be made available to all museum staff. This is not some idealized utopian vision; it is a necessary action step, which has become a clear need following the specific disasters that have struck museums in the United States over recent years.

In response to the many challenges of the Great Depression, the federal government's New Deal response held within it programs assisting museums and other cultural institutions. Museums that were the beneficiaries of the talents and efforts of workers hired by New Deal agencies received a significant boon during the difficult period. The cultural and intellectual boost became noticeable. The lesson here, insofar as history offers any clear pragmatic lessons at all, is that the federal government might productively respond to times of economic crisis by hiring workers to help improve museums and other cultural institutions. These institutions serve as important long-range economic anchors for many communities large and small. They often attract tourists who spend their dollars around town and, when functioning properly, provide employment for dedicated staffers. As we continue to debate the merits of the Green New Deal and recovery from the Covid-19 pandemic, museums should figure in prominently, as it is clear that they might benefit enormously from such inclusion and that communities would likewise be improved as a result. An outstanding array of well-qualified young professionals seeking opportunities in the present economic context are ready to take on the challenge.

Lessons drawn from the World War II era are perhaps less clear and made to seem more problematic in light of recent history. The Smithsonian Institution, for example, now has a State Department liaison to coordinate efforts to assist government agencies including the US military. Critically discussing the significance of such a reality is crucial, as it holds implications for cultural heritage in the United States and

around the world. Thoughtful reflection on the history and present state of museums rarely comprises an outright attack. In fact, many of the most critical voices speaking up about museums belong to people who care about them deeply. Cultural institutions benefit from the consistent care and evolution made possible through critical self-reflection.

Museums should embrace those who are most committed to their ongoing existence as cultural institutions, showing them more loyalty through dire situations than has most often been the case. Governments should invest in museums as often as possible, as they have reliably proven to be stable investments in both cultural and economic terms. Museum leaders should be encouraged to think about the needs of their surrounding communities more broadly and in a more inclusive manner. Taken together, this will make museums and other cultural institutions more durable and long-lasting in the future.

Museums are not perfect, but they do offer valuable touchstones for ongoing conversations. They can also evolve by moving in new directions and through sparking fresh dialogues. By embracing this role, museums can continue to renew their vitality in a changing world. With the death of the unchanging museum myth, museums can be reborn into something new, fresh, and even more important. Reconsidering these questions seems especially pressing as visitors return to public museum spaces. Recent surveys suggest that the visitors returning to museums are trending younger and more likely to be local residents than before the Covid-19 pandemic.[4] It is once again the case that opportunities

might be embedded within the challenges currently being presented.

While museums are constrained by their limited access to resources, they should work to respond to the interests and needs of their communities and audiences while offering space for these and other reflections. This sometimes means thinking differently about the collections they maintain, the spaces they occupy, or the communities they serve. The present era is also serving as a key moment for institutional self-reflection. Disasters and other crisis points, as difficult as they may be, can serve as crucial moments opening up broader contemplation and possible reinvention.

Those who care about museums should remember that they have faced many challenges throughout their pasts. In these times of distress, they have made difficult sacrifices and found creative solutions to evolve and live on. Relying on guiding principles and their greatest assets has helped museums to survive. Namely, museums have needed the foundational strength of community relationships, unique and valuable collections, and most importantly, committed staff. In showing commitment to these things, museums have often made possible great advances that benefit generations to follow. For museums to remain vital in US society in the future, they should remember to let their best guiding principles lead the way and build on the creative solutions they have found to face unpredictable challenges. In discovering inspiration and embracing the teachings drawn from carefully considering past experiences, museums can thrive in a more hopeful future.

ACKNOWLEDGMENTS

The first time I met Clara Platter of NYU Press was in early January 2020. During our initial meetings, we talked about a possible book on the present state of museums. Nobody could have fully anticipated the events that would follow during the months to come. As a parent who, like so many, suddenly found himself homebound and chasing a busy toddler for the next several months, I also discovered that the lengthy periods of pandemic-related lockdown gave me some additional time and space to think and read more about the history of museums and their present state.

Given the chaotic nature of the time in which this book was written, it is perhaps not surprising that a book originally imagined as being about the past, present, and possible future of museums in the United States soon became more focused on exploring the concept of *crisis* as it related to these same cultural institutions. I am extremely grateful to Clara for approaching me with the original idea and helping nurture this book into its present form, even as we went through this challenging stretch of history together. Her steadfast commitment to this project helped make it a reality. Thank you, Clara.

While this book was conceived and written during a fairly short period, it is based on research I began over a decade

ago in 2007, when I was a graduate student at the University of California, Berkeley. It turns out that I have accumulated more than my fair share of intellectual and social debts since then. I have benefited tremendously from conversations with my friends, other scholars, and professional colleagues. In this case, my colleagues who have spent years thinking about museums were especially helpful in developing this book.

Warm thanks to the Massachusetts Society of Professors and the College of Humanities and Fine Arts at the University of Massachusetts, Amherst, for their ongoing support. I am grateful to my colleagues in the Department of History at UMass–Amherst for providing an enriching scholarly home. And I would like to acknowledge here that earlier versions of portions of this book appeared in *Museum Anthropology*, the *Journal of the History of Collections*, and *Museum Review*.

A special thank you is due to my colleagues with Voices in Contemporary Art (VoCA), a New York–based nonprofit organization advancing conversations about the stewardship of contemporary art. Thanks especially to Lauren Shadford, Margaret Graham, and Chad Alligood. The list of individuals I have learned from through VoCA includes several experienced curators, art historians, and art conservators, including Jen Mergel, Steven O'Banion, Gwynne Ryan, and Gloria Sutton. My friends at VoCA have helped me to think more deeply about the world of modern and contemporary art. Their rich experience, commitment to interdisciplinary thinking, and good cheer have all vastly improved my life and career.

Many thanks to colleagues at the Smithsonian Institution, especially Candace Greene, Daisy Njoku, Gina Rappaport, and Dave Rosenthal. In addition to my friends and colleagues at the National Anthropological Archives, thank you to the staff at the Smithsonian Institution Archives.

At Berkeley, thank you to Richard Cándida Smith, Thomas Biolsi, and Randolph Starn. Thank you as well to David Hollinger and Cathryn Carson. I would also like to express my gratitude to the staff at the Bancroft Library and to the staff at the Phoebe A. Hearst Museum of Anthropology.

Shakti Castro, Trudie Cole, David Kessler, Jessica Scott, Vittorio Scutari, Travis Thompson, and Nancy Zook all contributed to the making of this book in some way. They patiently read drafts, offered useful feedback, and suggested different sources. I am extremely grateful to them for their invaluable insights.

An enormous thank-you is due to the anonymous reviewers who helped greatly improve this book. They helped catch errors and pointed to ways in which the argument might be strengthened. I sincerely appreciate their efforts.

My sister and brother-in-law, Elisa and Toby Spruce, supported this project in many ways, and I am grateful for their enthusiasm, invaluable feedback, and friendship.

Credit is also due to my amazing son, Owen Redman. We started visiting museums together soon after he was born. Learning how to see the world through his young eyes has helped me to appreciate museums in a new way.

Ashley Hawk Semrick is a wonderful partner and a close confidante. She is also an experienced teacher with a back-

ground in museum education. Through countless conversations about museums and their recent histories, she helped me clarify my thoughts about what this book might be and whom it might serve. I am extremely fortunate and grateful to have her in my life.

This book is dedicated to my mother, Cindy Redman, who, more than anyone else, is the reason why this book about museums exists. Thanks, Mom.

NOTES

INTRODUCTION

1. "Destructive Fire: Burning of the Smithsonian Institute [*sic*] at Washington. Serious Loss of Valuable Documents, Records, &c. The Library and Museum Saved," *New York Times*, January 25, 1865, 4.

2. Read in less general or symbolic terms, the omen might also have served as a specific warning about the danger of fire for museum collections. In 1900, a fire in storage destroyed archaeological materials at the Smithsonian. In 1951, a rare early collection of Hopi kachina dolls were destroyed in a fire in an exhibit case. The events were perhaps less reflective of random chance than of systemic neglect. The scholar Nancy J. Parezo reflects, "While there is occasionally money to collect objects it is, unfortunately, a truism that there is never enough money to care for them." Parezo, "The Formation of Ethnographic Collections: The Smithsonian Institution in the American Southwest," *Advanced in Archaeological Method and Theory* 10 (1987): 7.

3. For more on how historians have recently reconsidered museums and "new museum studies," see Randolph Starn, "A Historian's Brief Guide to New Museum Studies," *American Historical Review* 110, no. 1 (February 2005): 68–98.

4. *The Merriam-Webster Dictionary*, rev. ed. (Springfield, MA: Merriam-Webster, 2004), s.v. "crisis."

5. In 1995, the cultural historian Neil Harris reflected on the subject of museums and controversy, arguing that to that point, most historians writing about the history of museums had ignored the subject of controversy. For my treatment of the story in this book, I conceptualize hotly controversial moments in museum history, such as the 1970 Artists' Strike and Smithsonian Enola Gay episode of the mid-1990s as potential "crisis" moments for the museum as an institution and an idea. Aspiring to build on Harris's idea, this book extends the idea of

museum crisis (including controversy) further back in time and across different institutions and disciplines. See Harris, "Museums and Controversy: Some Introductory Reflections," *Journal of American History* 82, no. 3 (December 1995): 1102–1110.

6. John Simmons, *Museums: A History* (Lanham, MD: Rowman and Littlefield, 2016), 170.

7. Simmons, 139.

8. While the balance of museum histories available in the literature focus their weight on the nineteenth century, if not earlier, some of these histories extend their exploration into the twentieth century. See, for example, Eilean Hooper-Greenhill, *Museums and the Shaping of Knowledge* (London: Routledge, 1992); Tony Bennett, *The Birth of the Museums: History, Theory, Politics* (London: Routledge, 1995); Steven Conn, *Museums in American Intellectual Life, 1876–1926* (Chicago: University of Chicago Press, 2000); and Simmons, *Museums*. Yet by focusing predominantly on what the historian Germaine Bazin has called "The Age of Museums" between 1789 and 1900, much of the more recent story has been lesser told in the available literature (Bazin's description is noted in Simmons, *Museums*, 175). Notably, only 4 percent of US museums were in existence before 1900 (Simmons, *Museums*, 178).

1. WAR, COLD, UNREST, STRIKES, AND EPIDEMICS

1. American Museum of Natural History, *Annual Report, 1920*, 46.

2. For more on this discourse see Conn, *Museums and American Intellectual Life*.

3. Smithsonian Institution, *Annual Report, 1920*, 40.

4. Simmons, *Museums*, 151.

5. By "historic house museum," I mean one of the many historic homes in the United States converted into a museum, for example, the Betsy Ross House or the Mark Twain House. Simmons, 155. See also Seth Bruggeman, ed., *Born in the U.S.A.: Birth, Commemoration, and American Public Memory* (Amherst: University of Massachusetts Press, 2012).

6. Simmons, *Museums*, 155, 161.

7. Simmons, 179. The museum thinker John Cotton Dana responded to these same estimates by figuring that only fifty to eighty of these

listed museums were "live" or active in the full range of museum-related activities. Dana, *The New Museum* (Woodstock, NY: Elm Tree, 1917), 9.

8. Simmons, *Museums*, 182–183.

9. For additional context in regard to the history of museums and the history of paleontology, see Lukas Rieppel, *Assembling the Dinosaur: Fossil Hunters, Tycoons, and the Making of a Spectacle* (Cambridge, MA: Harvard University Press, 2019).

10. As quoted in Simmons, *Museums*, 193.

11. Simmons, 193.

12. Dana, *New Museum*, 9.

13. Dana, 33.

14. Dana, 36.

15. Marjorie Schwarzer, "Lessons from History: Museums and Pandemic," *Center for the Future of Museums Blog*, March 10, 2020, www.aam-us.org.

16. The AMNH, for example, noted in an annual report reflecting the year 1917 that the museum was already putting plans into place for the coming war. Museum staff were already joining the active service. Others were contributing scientific work. American Museum of Natural History, *Annual Report, 1917*, 24.

17. Pennsylvania Museum and School of Industrial Art, *Annual Report, 1917*, 32.

18. Smithsonian Institution, *Annual Report, 1919*, 3.

19. Pennsylvania Museum and School of Industrial Art, *Annual Report, 1917*, 10.

20. Pennsylvania Museum and School of Industrial Art, 17.

21. Dorothy M. Browne, "New York City Museums and Cultural Leadership, 1917–1940" (PhD diss., City University of New York, 2008), 17.

22. Appendix 4, in *Curators, Collections, and Contexts: Anthropology at the Field Museum, 1893–2002*, ed. Stephen E. Nash and Gary M. Feinman (Chicago: Field Museum of Natural History, 2003), 292.

23. For a recent treatment providing additional context on the World War I, see Jörn Leonhard, *Pandora's Box: A History of the First World War* (Cambridge, MA: Harvard University Press, 2018). As referenced elsewhere, a classic text on the United States during World

War I is David M. Kennedy, *Over Here: The First World War and American Society* (Oxford: Oxford University Press, 1980).

24. Harlan I. Smith, "The Work of Museums in War Time," *Scientific Monthly* 6, no. 4 (April 1918): 362.

25. Smith, 363.

26. Smith, 364.

27. Smith, 364.

28. Smith, 364.

29. Smith, 367.

30. See Kennedy, *Over Here*.

31. "Eastman Case from Shooting to Verdict," *Boston Sunday Post*, May 12, 1901, 15.

32. "Scientist Drowns at Long Beach," *New York Times*, September 30, 1918, 9.

33. For more on the pandemic and its history, see Alfred W. Crosby, *America's Forgotten Pandemic: The Influenza of 1918* (Cambridge: Cambridge University Press, 2003).

34. Pennsylvania Museum and School of Industrial Art, *Annual Report, 1920*, 66–67.

35. National Museum, *Annual Report, 1921*, 22.

36. American Museum of Natural History, *Annual Report, 1920*, 46.

37. New York State Museum, *Report of the Director of the State Museum of New York* (1919), 104–105. Jesse Cornplanter (1889–1957) went on to become an accomplished artist, author, and noted leader in the Seneca and Iroquois communities.

38. Museum of Fine Arts Boston, *Annual Report, 1920*, 11. The museum's attendance had gone from 280,189 in 1919 to 288,312 in 1920. This represented a modest, but notable, increase of 1 percent over the previous year.

39. Pennsylvania Museum and School of Industrial Art, *Annual Report, 1920*, 33.

40. American Museum of Natural History, *Annual Report, 1920*, 111.

41. Pennsylvania Museum and School of Industrial Art, *Annual Report, 1918*, 9.

42. Dana, *New Museum*, 54.

43. Simmons, *Museums*, 184.

44. Museum of Fine Arts Boston, *Annual Report, 1920*, 83.

2. THE HEARST MUSEUM OF ANTHROPOLOGY AND THE GREAT DEPRESSION

1. Several recent treatments of Franz Boas's life and legacy have appeared in the available literature. See Charles King, *Gods of the Upper Air: How a Circle of Renegade Anthropologists Reinvented Race, Sex, and Gender in the Twentieth Century* (New York: Doubleday, 2019). See also Rosemary Levy Zumwalt, *Franz Boas: The Emergence of the Anthropologist* (Lincoln: University of Nebraska Press, 2019).

2. George W. Stocking, introduction to *Objects and Others: Essays on Museums and Material Culture*, ed. George W. Stocking (Madison: University of Wisconsin Press, 1985), 8.

3. Burton Benedict, "Anthropology and the Lowie Museum," *Museum Anthropology* 15, no. 4 (1991): 26.

4. Ira Jacknis, "Alfred Kroeber as Museum Anthropologist," *Museum Anthropology* 17, no. 2 (1993): 27.

5. I write more about Kroeber and his fraught legacy in California in Samuel J. Redman, *Prophets and Ghosts: The Story of Salvage Anthropology* (Cambridge, MA: Harvard University Press, 2021).

6. UC Museum of Anthropology, *Annual Report*, 1946, Hearst Museum Archives, UC Berkeley, 7–8.

7. UC Museum of Anthropology, *Annual Report, 1920*, Hearst Museum Archives, UC Berkeley.

8. Harvard University, *Annual Report, 1932–1933*, 296.

9. See Joan Baldwin, "The Question of Gender: The 'Unseen' Problem in Museum Workplaces," American Alliance of Museums, August 28, 2017, www.aam-us.org. See also Victoria Turner, "The Factors Affecting Women's Success in Museum Careers: A Discussion of the Reasons More Women Do Not Reach the Top, and Strategies to Promote Their Future Success," *Journal of Conservation and Museum Studies* 8 (2002): 6–10.

10. A memorandum in the Kroeber Papers at the Bancroft Library outlines a number of lecture programs for students in grades 5–8. Frame 367, Reel 174, Folder 40, Memos, BNEG 1840:173, A. L. Kroeber Papers, BANC Film 2049 BANC MSS C-B 925, Bancroft Library, UC Berkeley.

11. On the relocation to the Civil Engineering Building, see Map of Floor Plans of Museum Building (Old Civil Engineering Building), 1931, Folder: Museum History, Museum Move from San Francisco to Berkeley, 1931, Hearst Museum Historical Records, Bancroft Library, UC Berkeley. On exhibitions, see UC Museum of Anthropology, *Report to President Robert Gordon Sproul for the Year Ending June 30, 1939*, 3. See also Correspondence and Contents in Each Room, Folder: Museum History, Museum Move from San Francisco to Berkeley, 1931, Hearst Museum Historical Records, Bancroft Library, UC Berkeley.

12. Alfred Kroeber to Robert Gordon Sproul, August 14, 1931, CU-5, Series 2, University of California, President, 1931, 83-100A, Anthropology, Bancroft Library, UC Berkeley.

13. Julian Steward, Ann Gibson, and John Rowe, "Alfred Louis Kroeber, 1876–1960," *American Anthropologist* 63, no. 5 (1961): 1045.

14. Benedict, "Anthropology and the Lowie Museum," 27.

15. Jacknis, "Alfred Kroeber as Museum Anthropologist," 27.

16. Hearst Museum of Anthropology, Accession Files 657, 658, and 664.

17. Gifford to E. B. McFarland, October 20, 1939, Box 185–186, CU-23, Department of Anthropology, University Archives, Bancroft Library, UC Berkeley.

18. University of California surveying efforts built on earlier surveying efforts organized by the federal government and supported through New Deal programs, not just in California but around the country. For additional context see Bernard K. Means, ed., *Shovel Ready: Archaeology and Roosevelt's New Deal for America* (Tuscaloosa: University of Alabama Press, 2013).

19. Memorandum, "Recapitulation of Archaeological Exploration by the Department of Anthropology in California, Nevada, Oregon, 1901–1945," November 15, 1945, Frame 367, Reel 174, BNEG 1840:173, Folder 40, Memos, A. L. Kroeber Papers, BANC Film 2049 BANC MSS C-B 925, Bancroft Library, UC Berkeley.

20. Kroeber to C. T. Seltman, October 14, 1927, Box 185–186, Department of Anthropology, CU-23, University Archives, Bancroft Library, UC Berkeley.

21. Kroeber to E. Wayne Galliher, October 29, 1931, Box 185–186, Department of Anthropology, CU-23, University Archives, Bancroft Library, UC Berkeley.

22. President Sproul's efforts can be seen in the records for the Hearst Museum, Accession Files, Accession 671.

23. The MEP advertised these exhibitions in various publications, hoping that institutions would continue to embrace the program. See Folder: Diorama, Box 14, Series 17: Division of Ethnology Manuscript and Pamphlet File, Records of the Department of Anthropology / U.S. National Museum of Natural History, National Anthropological Archives, Smithsonian Institution, Washington, DC.

24. Francis H. Taylor, "Suspension of the WPA Museum Project," *Metropolitan Museum of Art Bulletin* 37, no. 6 (1942): 164.

25. See Edward W. Gifford, "California Shell Artifacts," *University of California Anthropology Records* 9, no. 1 (1946); and Gifford, "Early Central and Anasazi Shell Artifact Types," *American Antiquity* 15 (1949).

26. UC Museum of Anthropology, *Annual Report, 1940*, 6.

27. UC Museum of Anthropology, *Annual Report, 1941*, 6.

28. The inquiries are found in Box 185–186, Department of Anthropology, CU-23, University Archives, Bancroft Library, UC Berkeley.

29. UC Museum of Anthropology, *Annual Report, 1941*, 6.

30. UC Museum of Anthropology, *Annual Report, 1943*, 9–12; UC Museum of Anthropology, *Annual Report, 1945*, 7–8.

31. For additional context on the GI Bill, see Kathleen J. Frydl, *The GI Bill* (Cambridge: Cambridge University Press, 2009).

32. UC Museum of Anthropology, *Annual Report, 1933*, 2.

33. Warren Haskin, Stephen E. Nash, and Sarah Coleman, "A Chronicle of Field Museum Anthropology," in *Curators, Collections, and Contexts: Anthropology at the Field Museum, 1893–2002*, ed. Stephen E. Nash and Gary M. Feinman (Chicago: Field Museum of Natural History, 2003), 70–80.

34. Smithsonian Institution, *Annual Report, 1936*, 22.

35. Smithsonian Institution, *Annual Report, 1938*, 26.

36. Memorandum, H. W. Kreiger, "Report on W.P.A. Assistance, Division of Ethnology, United States National Museum," June 22, 1939, Folder: Works Progress Administration, Box 86, Series 17: Division of Ethnology Manuscript and Pamphlet File, Records of the

Department of Anthropology / U.S. National Museum / National Museum of Natural History, National Anthropological Archives, Smithsonian Institution.

37. For more on the Smithsonian's use of New Deal labor in archaeology, see Archaeological Reports, 1934–1942, Manuscript 844, Folder: Works Progress Administration, Box 86, Series 17: Division of Ethnology Manuscript and Pamphlet File, Records of the Department of Anthropology / U.S. National Museum / National Museum of Natural History, National Anthropological Archives, Smithsonian Institution. For additional context on this program see Means, *Shovel Ready*.

38. Some records do, in fact, describe government works program employees falling asleep on the job or mishandling museum objects. Such complaints were rare, but with a large-scale influx of new labor, problems were bound to be observed. See Folder: Works Progress Administration, Box 86, Series 17: Division of Ethnology Manuscript and Pamphlet File, Records of the Department of Anthropology / U.S. National Museum / National Museum of Natural History, National Anthropological Archives, Smithsonian Institution.

39. Statistics based on the UC Museum of Anthropology annual reports for the years 1939–1946.

40. UC Museum of Anthropology, *Annual Report, 1940*, 3.

41. Attendance Figures, Announcements, Mailing Lists of Local School Teachers, Anthropology Museum Exhibits on Primitive Art, Folder: Museum History, Exhibits, 1935–1941, Hearst Museum Historical Records, Bancroft Library, UC Berkeley.

42. UC Museum of Anthropology, *Annual Report, 1949*, 11.

43. UC Museum of Anthropology, *Annual Report, 1946*, 4–5.

44. UC Museum of Anthropology, 11.

45. Jacknis, "Alfred Kroeber as Museum Anthropologist," 30.

3. THE SMITHSONIAN AND MUSEUMS DURING THE WORLD WAR II ERA

1. Memorandum, "Selected Examples to Illustrate the Nature of Technical Information and Assistance Furnished by the Smithsonian Institution to the Army, Navy, and War Agencies since Pearl Harbor," June 30, 1943, Folder: War Committee Reports, Box 1, Carl

W. Mitman Papers, Smithsonian Institution Archives, Washington, DC.

2. A worthwhile, if incomplete, summary of museums in the United States mobilizing for war can be found in a report published by the Library of Congress in 1952: Nelson R. Burr, *Safeguarding Our Cultural Heritage: A Bibliography on the Protection of Museums, Works of Art, Monuments, Archives, and Libraries in Time of War* (Washington, DC: Library of Congress, 1952).

3. Following the political scientist Arthur A. Stein, "When a nation goes to war, it must utilize a variety of resources in its struggle. This international national undertaking is generally referred to as mobilization. Here, mobilization is defined as a process by which national elites rapidly gain control of resources for the purpose of waging war." Stein, *The Nation at War* (Baltimore: John Hopkins University Press, 1978), 11.

4. The historian Jeffrey Trask reminds us, "Debates about the civil role of museums—whether museums should serve primarily as places to preserve the sacred status of fine art and reify cultural capital or as institutions to promote social cohesion through democratic programming and educational outreach—continue to this day." Indeed, the Progressive-era ideals confronting museums established in the Gilded Age pushed some institutions to establish agendas of advancing the civic capacity of museum visitors. By World War II, museums in the United States were already positioned to expand and reimagine their evolving roles in civil society. Trask, *Things American: Art Museums and Civic Culture in the Progressive Era* (Philadelphia: University of Pennsylvania Press, 2011), 3.

5. See Lynn H. Nicholas, *The Rape of Europa: The Fate of Europe's Treasures in the Third Reich and the Second World War* (New York: Knopf, 1994). An example of the concern expressed about cultural artifacts in the immediate aftermath of war can be found in Alma Wittlin, "Museums in War-Time," *Contemporary Review* 168 (July–December 1945): 103–108. See also Fiske Kimball, "Museums Abroad since the War," *Philadelphia Museum Bulletin* 44, no. 219 (November 1948): 2–15.

6. In the aftermath of World War II, museum leaders in the United States pointed to the destruction in Europe as a rationale for

advancing international cooperation between museums and other cultural institutions. In a letter to the editor responding to an essay critical of UNESCO, the San Francisco Museum of Art director Grace L. McCann Morley writes, "International co-operation seems the World's best hope for peace just now, and each means such as UNESCO offers toward that end, seems precious. I am inclined to believe, after seeing the heart of London, war destruction in France and Germany, that we had better all make our international organizations work if we want art, or indeed any civilized life to survive." Morley, "UNESCO and the Future of Museums," *Burlington Magazine for Connoisseurs* 89, no. 530 (May 1947): 136–137.

7. Kimball, "Museums Abroad since the War," 2–15.

8. On the precautions taken by the Smithsonian and the news that the museums and art galleries were working to remain open, see "Museums, Art Galleries Here to Stay Open," *Washington Post*, January 3, 1942, 19. By contrast, the Metropolitan Museum in New York started taking steps to protect artwork against air raids months before December 7, 1941, and moving some artwork outside the city altogether. These efforts seemed more crucial after the events at Pearl Harbor in early December 1941. See "Museums Plan to Protect Art Treasures in Raids," *New York Times*, December 10, 1941, 17; and "Art Museum to Send Treasures to Air Raid Refuge in Country," *New York Times*, January 20, 1942, 21.

9. Trask, *Things American*, 127.

10. *A Guide to Balboa Park San Diego California*, American Guide Series (San Diego: Neyenesch, 1941), 3.

11. "San Diegans made many sacrifices during the war years, but one that long-time residents still remember was the temporary loss of much of Balboa Park. In early 1942, the park along El Prado became a restricted zone for use as expanded training and hospital facilities by the Naval Training Station and the nearby Naval Hospital. Their occupation of the central corridor through the park forced museums to dismantle and store most of their collections. The Museum of Man, Natural History Museum and Museum of Art removed more than a million artifacts and works of art for storage in museum basements, private museums outside the city, schools and other 'undisclosed' locations. Artifacts too large to travel were enclosed

with protective walls. Thousands of hospital beds soon filled former exhibition galleries. During the war years, recovering patients could be found swimming in the Lily Pond, while sailors drilled in formation along the park's open promenades. Although some areas like the zoo remained open to the public, most of Balboa Park remained off limits until peacetime returned." Lucinda Eddy, "War Comes to San Diego," *Journal of San Diego History* 39, nos. 1–2 (Winter–Spring 1993): 76.

12. Herbert Katz and Marjorie Katz, *Museums, U.S.A.: A History and Guide* (Garden City, NY: Doubleday, 1965), 4–5.

13. Smithsonian Institution, *Annual Report, 1940*, 27.

14. Carl W. Mitman to C. G. Abbot, April 10, 1942, Folder: War Committee Correspondence, Box 1, Carl W. Mitman Papers, Smithsonian Institution Archives.

15. Form letter, C. G. Abbot, May 16, 1942, Folder: War Committee Correspondence, Box 1, Carl W. Mitman Papers, Smithsonian Institution Archives.

16. Smithsonian Institution, *Annual Report, 1942*, 2.

17. Smithsonian Institution, 3.

18. Smithsonian Institution, 3.

19. Smithsonian Institution, 3.

20. Smithsonian Institution, *Annual Report, 1943*, 1.

21. Smithsonian Institution, 2.

22. Smithsonian War Committee, "Selected Examples to Illustrate the Nature of Technical Information and Assistance Furnished by the Smithsonian Institution to the Army, Navy, and War Agencies since Pearl Harbor," June 30, 1943, Folder: War Committee Reports, Box 1, Carl W. Mitman Papers, Smithsonian Institution Archives.

23. A list of objects and information requested of the Smithsonian by the US military can be found in a single, large memorandum: Smithsonian War Committee, "Selected Examples."

24. David H. Price, *Anthropological Intelligence: The Deployment and Neglect of American Anthropology in the Second World War* (Durham, NC: Duke University Press, 2008), 97.

25. Theodore Low, "What Is a Museum?," in *Reinventing the Museum: Historical and Contemporary Perspectives on the Paradigm Shift*, ed. Gail Anderson (Lanham, MD: AltaMira, 2004), 30.

26. Low, 31.

27. Low, 42.

28. Ada Rainey, "Museums Help Morale in Wartime," *Washington Post*, January 4, 1942, L7.

29. American Museum of Natural History, *Annual Report, 1944*, 1.

30. American Museum of Natural History, 18.

31. "Museum Exhibits War and Its Opposites," *Los Angeles Times*, January 9, 1944, C1.

32. A. E. Parr, "In Transition," in American Museum of Natural History, *Annual Report, 1945*, 9.

33. Parr, 9.

34. Quoted in Katz and Katz, *Museums, U.S.A.*, 130.

35. Francis Henry Taylor, *Babel's Tower: The Dilemma of the Modern Museum* (New York: Columbia University Press, 1945), 8.

36. Taylor, 52.

37. Taylor, 53.

38. Walter Lippmann, "The Museum of the Future," *Atlantic* 184, no. 4 (October 1948): 70–72.

39. Walter Lippmann, *Public Opinion* (New York: Harcourt, Brace, 1922), 164–165.

40. Memorandum, "The Smithsonian Institution's Part in World War II," March 15, 1945, 20, Folder: War Committee Reports, Box 1, Carl W. Mitman Papers, Smithsonian Institution Archives.

41. John F. Embree, *The Japanese*, Smithsonian Institution War Background Studies 7 (Washington, DC: Smithsonian Institution, 1943). At the time of publication, Embree was an assistant professor of Anthropology at the University of Toronto. Embree, an American, had conducted fieldwork in Japan in the late 1930s. Ruth Benedict, for her own part, noted in the preface to her work, "My thanks are also due to the Office of War Information, which gave me the assignment on which I report in this book." Benedict, *Chrysanthemum and the Sword: Patterns of Japanese Culture* (Boston: Houghton Mifflin, 2005), vi.

42. For additional context on the role of anthropologists (like Ruth Benedict and Margaret Mead) and other social scientists and state formation during World War II, see James T. Sparrow, *Warfare State:*

World War II Americans and the Age of Big Government (Oxford: Oxford University Press, 2011), 67.

43. Benedict cites Embree on several occasions in her book, for example, Benedict, *Chrysanthemum and the Sword*, 83.

44. Embree, who studied under important anthropologists at the University of Chicago, died in a tragic accident at a fairly young age, cutting his career, and his influence, short. For biographical information on John Embree, see John Pelzel, "John Fee Embree, 1908–1950," *Far Eastern Quarterly* 11, no. 2 (February 1952): 219–225. See also Fred Eggan, "John Fee Embree, 1908–1950," *American Anthropologist* 53, no. 3 (July–September 1951): 376–382.

45. This sentiment is echoed by Ian Buruma in his recent foreword to a republication of Benedict's work, although he does not compare Benedict's writing to Embree's directly. Burma, "Foreword to the Mariner Books Edition," in Benedict, *Chrysanthemum and the Sword*, vii–xii.

46. As mentioned earlier, Embree's *War Background Studies* pamphlet became a larger book: John F. Embree, *The Japanese Nation: A Social Survey* (New York: Farrar and Rinehart, 1945). John Reed Swanton's contributions to the *War Background Studies* series, on the other hand, are not even listed in a prominent bibliography published on the occasion of his death. See Julian H. Steward, *John Reed Swanton, 1873–1958: A Biographical Memoir* (Washington, DC: National Academies Press, 1960).

4. 1970 ART STRIKE AND NEW MUSEUM PERSPECTIVES

1. The museum has also been described as the second-largest museum in the world (after only the Louvre). Simmons, *Museums*, 193–194.

2. In a draft statement, the group wrote, "The artists of New York, along with the many art writers, gallery owners, and museum staff—in memorium to those slain in Orangeburg, S.C., Kent State, Jackson State and Augusta, as an expression of shame and outrage at our government's policies of racism, war and repression—are asking all museums, galleries, art schools and institutions in New York to close in a general strike on this day, Friday, May 22, 1970." Announcement, New York Artists Strike Against War, Racism, and

Repression, 1970, Michael Goldberg Papers, 1942–1981, Archives of American Art, Smithsonian Institution, Washington, DC.

3. Grace Glueck, "500 in Art Strike Sit on Steps of Metropolitan," *New York Times*, May 23, 1970, 18.

4. For more on the context of intellectuals in New York, a classic interpretation can be found in Thomas Bender, *New York History: A History of Intellectual Life in New York City from 1750 to the Beginnings of Our Own Time* (Baltimore: Johns Hopkins University Press, 1988). For more on New York's monied elite, see Sven Beckert, *The Monied Metropolis: New York City and the Consolidation of the American Bourgeoisie, 1850–1896* (Cambridge: Cambridge University Press, 2001).

5. Quoted in Neil Harris, "Museums and Controversy: Some Introductory Reflections," *Journal of American History* 82, no. 3 (December 1995): 1104.

6. Harris, 1104.

7. Simmons, *Museums*, 195.

8. Simmons, 194, 200–201.

9. Harris, "Museums and Controversy," 1107.

10. Metropolitan Museum of Art, *Annual Report of the Trustees, 1970*, 3.

11. A series of books explores the entire collection. See, for example, Richard R. Brettell, Paul Hayes Tucker, and Natalie H. Lee, *The Robert Lehman Collection at the Metropolitan Museum of Arts*, vol. 3, *Nineteenth- and Twentieth-Century Paintings in the Robert Lehman Collection* (Princeton, NJ: Princeton University Press, 2010).

12. Barry N. Schwartz, "The Metropolitan Museum of Art: Cultural Power in a Time of Crisis," *Metropolitan Museum of Art Bulletin* 27, no. 5 (January 1969): 262–264 (quote on 262).

13. For additional context on the *Harlem on My Mind* controversy in 1969, see Harris, "Museums and Controversy," 1107. For added perspective on how this event fit within the larger evolution of Black representation in the art museum, see Bridget R. Cooks, *Exhibiting Blackness: African Americans and the American Art Museum* (Amherst: University of Massachusetts Press, 2011). See also Susan E. Cahan, *Mounting Frustration: The Art Museum in the Age of Black Power* (Durham, NC: Duke University Press, 2016).

14. Simmons, *Museums*, 249.

15. Simmons, 195.

16. "Controversy became part of the institution's strategy" (Harris, "Museums and Controversy," 1107). For MoMA, this move represented an approach that worked against museum orthodoxy. For example, Sarah Maza says, "Museum directors rarely court or welcome controversies that can cost them their jobs." Maza, *Thinking about History* (Chicago: University of Chicago Press, 2017), 137.

17. Richard Cándida Smith, "Modern Art and Oral History in the United States: A Revolution Remembered," *Journal of American History* 78, no. 2 (September 1991): 601.

18. For additional context and a comparative look at California, see Richard Cándida Smith, *Utopia and Dissent: Art, Poetry, and Politics in California* (Berkeley: University of California Press, 1995). See also Smith, *The Modern Moves West: California Artists and Democratic Culture in the Twentieth Century* (Philadelphia: University of Pennsylvania Press, 2009).

19. Smith, "Modern Art and Oral History," 602.

20. Glueck, "500 in Art Strike Sit on Steps of Metropolitan," 18.

21. For additional context see Smith, "Modern Art and Oral History," 598–606.

22. The artwork in question, in this initial episode, was created by the Greek artist Panayiotis Vassilakis, better known as Takis. For more, see Michelle Elliott, "From the Archives: Faith Ringgold, the Art Workers Coalition, and the Fight for Inclusion at the Museum of Modern Art," Modern Museum of Art, July 29, 2016, www.moma. org.

23. Smith, "Modern Art and Oral History," 599.

24. Schwartz, "Metropolitan Museum of Art," 264.

25. See Helen Anne Molesworth, M. Darsie Alexander, and Julia Bryan-Wilson, *Work Ethic* (University Park: Pennsylvania State University Press, 2003).

26. Grace Glueck, "Strike Front Keeps Its Cool," *New York Times*, July 5, 1970, 65.

27. Glueck, "500 in Art Strike Sit on Steps of Metropolitan," 18.

28. Glueck, "Strike Front Keeps Its Cool," 65.

29. Glueck, "500 in Art Strike Sit on Steps of Metropolitan," 18.

30. Glueck, 18.
31. Glueck, "Strike Front Keeps Its Cool," 65.
32. Glueck, "500 in Art Strike Sit on Steps of Metropolitan," 18.
33. Glueck, 18.
34. Glueck, 18.
35. New York Artists Strike Against Racism, Repression, and War, New York Artists' Strike press release, ca. 1970, Michael Goldberg Papers, 1942–1981, Archives of American Art, Smithsonian Institution, Washington, DC.
36. Glueck, "Strike Front Keeps Its Cool," 65.
37. Glueck, 65.
38. Smith, "Modern Art and Oral History," 605–606.
39. Hoving, perhaps ironically, had been publicly chided for his having inserted his own political views into the making of an art exhibition. Perhaps this context helps explain his tepid response to the 1970 art strike. See Harris, "Museums and Controversy." Most sources suggest that Hoving was personally incapable of changing course. This was suggested by his offering a tepid apology for earlier mistakes and his failure either to take ownership of the situation or to recognize the need to move forward in a more collaborative manner.
40. Glueck, "Strike Front Keeps Its Cool," 65.
41. Glueck, 65.
42. Glueck, 65.
43. Glueck, 65.

5. THE CULTURE WARS OF THE 1980S AND 1990S

1. Relevant works on this history and related controversies in US history can be read in David Glassberg, *Sense of History: The Place of the Past in American Life* (Amherst: University of Massachusetts Press, 2001); Eric Foner, *Who Owns History? Rethinking the Past in a Changing World* (New York: Hill and Wang, 2003); Robert C. Post, *Who Owns America's Past? The Smithsonian and the Problem of History* (Baltimore: Johns Hopkins University Press, 2017); and Chip Colwell, *Plundered Skulls and Stolen Spirits: Inside the Fight to Reclaim Native America's Culture* (Chicago: University of Chicago Press, 2017). A review essay unpacking some of the many new books

appearing in print not long after the *Enola Gay* controversy can be read in William S. Pretzer, "Reviewing Public History in Light of the '*Enola Gay*,'" *Technology and Culture* 39, no. 3 (1998): 457–461.

2. Simmons, *Museums*, 151.

3. For more on how the *Enola Gay* incident influenced the Smithsonian in the long term, see Alexandra M. Lord, "Finding Connections," *Public Historian* 40, no. 2 (2018): 9–22.

4. The survey was published by the American Association of Museums and based on a survey starting in 1987. Simmons, *Museums*, 223.

5. A now classic treatment on the Native American Graves Protection and Repatriation Act (NAGPRA) can be read in Devon A. Mihesuah, ed., *Repatriation Reader: Who Owns American Indian Remains?* (Lincoln: University of Nebraska Press, 2000). See also Kathleen Fine-Dare, *Grave Injustice: The American Indian Repatriation Movement and NAGPRA* (Lincoln: University of Nebraska Press, 2002). A recent, brief, and general overview of NAGPRA in museum history can be read in Simmons, *Museums*, 246–248. For more detail, see Stephen E. Nash and Chip Colwell, "NAGPRA at 30: The Effects of Repatriation," *Annual Review of Anthropology* 49 (2020): 225–239. For a different perspective, both visually and in terms of expert authorial voice, see the comic book series by Sonya Atalay, Jen Shannon, and John Swogger, "Journeys to Complete the Work," 2017, https://nagpracomics.weebly.com. See also Sonya Atalay, "Braiding Strands of Wellness: How Repatriation Contributes to Healing through Embodied Practice and Storywork," *Public Historian* 41, no. 1 (2019): 78–89.

6. See National Park Service, "Native American Graves Protection and Repatriation Act," accessed March 14, 2021, www.nps.gov.

7. See, for example, Ann Fabian, *The Skull Collectors: Race, Science, and America's Unburied Dead* (Chicago: University of Chicago Press, 2010). See also Samuel J. Redman, *Bone Rooms: From Scientific Racism to Human Prehistory in Museums* (Cambridge, MA: Harvard University Press, 2016).

8. For more on the connections, see Fine-Dare, *Grave Injustice*, 30–40. On differing attitudes, see also Simmons, *Museums*, 247.

9. I have already noted in this book how the 1970 art strike protesters were aware of the problem of museums holding sacred materials and

demanded their return in the list of demands they gave to the AAM. For more on the deeper history of tensions surrounding these collections, see Fine-Dare, *Grave Injustice.*

10. William N. Fenton, "The New York State Wampum Collection: The Case for the Integrity of Cultural Collections," *Proceedings of the American Philosophical Society* 115, no. 6 (December 30, 1971): 437–461.

11. Mihesuah, introduction to *Repatriation Reader*, 1–2.

12. Simmons, *Museums*, 234–238.

13. Amy Lonetree, *Decolonizing Museums: Representing Native America in National and Tribal Museums* (Chapel Hill: University of North Carolina Press. 2012).

14. For additional context, see Simmons, *Museums*, 246–248.

15. Much has been written on NAGPRA in the past thirty years. This list includes several, highly readable, examples: David Hurst Thomas, *Skull Wars: Kennewick Man, Archaeology, and the Battle for Native American Identity* (New York: Basic Books, 2000), 214–215; Sangita Chari and Jaime M. N. Lavallee, eds., *Accomplishing NAGPRA: Perspectives on the Intent, Impact, and Future of the Native American Graves Protection and Repatriation Act* (Corvallis: Oregon State University Press, 2013); Fine-Dare, *Grave Injustice*; Mihesuah, *Repatriation Reader*; Stephen E. Nash and Chip Colwell-Chanthaphonh, "NAGPRA after Two Decades," *Museum Anthropology* 32, no. 2 (Fall 2010): 99–104; Chip Colwell-Chanthaphonh, "The Work of Repatriation in Indian Country," *Human Organization* 71, no. 3 (Fall 2012): 278–291; and, more recently, Colwell, *Plundered Skulls and Stolen Spirits.*

16. Colwell, *Plundered Skulls and Stolen Spirits*, 7.

17. Simmons, *Museums*, 247.

18. Little Traverse Bay Bands of Odawa Indians, *Finding Our Way Home: NAGPRA Handbook* (Harbor Springs, MI: Little Traverse Bay Bands of Odawa Indians, 2012), 2.

19. Colwell, *Plundered Skulls and Stolen Spirits*, 7.

20. Simmons, *Museums*, 247–248.

21. Colwell, *Plundered Skulls and Stolen Spirits*, 7.

22. See, for example, Richard H. Kohn, "History and the Culture Wars: The Case of the Smithsonian Institution's *Enola Gay* Exhibition,"

Journal of American History 82, no. 3 (December 1995): 1036; and Steven Conn, "Science Museums and the Culture Wars," in *A Companion to Museum Studies*, ed. Sharon Macdonald (Oxford, UK: Blackwell, 2006). An overview of these events as they related to history can be found in Richard Jensen, "The Culture Wars, 1965–1995: A Historian's Map," *Journal of Social History* 29 (1995): 17–37.

23. James Davison Hunter, *Culture Wars: The Struggle to Define America* (New York: Basic Books, 1991).

24. For additional context in a highly readable book, see Stephen T. Asma, *Stuffed Animals and Pickled Heads: The Culture and Evolution of Natural History Museums* (Oxford: Oxford University Press, 2003).

25. For more, see Roger D. Launius, "American Memory, Culture Wars, and the Challenge of Presenting Science and Technology in a National Museum," *Public Historian* 29, no. 1 (2007): 13–30.

26. Kohn, "History and the Culture Wars," 1036.

27. The *Enola Gay* incident has been written about by historians and others extensively. Already mentioned are Kohn, "History and the Culture Wars," 1036–1063; and Pretzer, "Reviewing Public History," 457–461. See also Stanley Goldberg, "The *Enola Gay* Affair: What Evidence Counts When We Commemorate Historical Events?," *Osiris* 14, no. 1 (1999): 176–186; Martin Harwit, *An Exhibit Denied: Lobbying the History of the* Enola Gay (New York: Springer Books, 1996); Edward T. Linenthal and Tom Engelhardt, eds., *History Wars: The* Enola Gay *and Other Battles for the American Past* (New York: Metropolitan Books, 1996); and, more recently, Robert Newman, Enola Gay *and the Court of History* (New York: P. Lang, 2004).

28. Newsroom for the Smithsonian, "Visitor Stats," accessed June 10, 2021, www.si.edu.

29. Timothy W. Luke, *Museum Politics: Power Plays at the Exhibition* (Minneapolis: University of Minnesota Press, 2002), 31.

30. By "Good War," I am referencing the historian Studs Terkel's classic formulation questioning whether any war, no matter how well intentioned, can possibly be "good." Terkel, *The Good War: An Oral History of World War II* (New York: New Press, 1997).

31. James Risen, "For Two Smithsonian Curators, the *Enola Gay*'s Mission Launched the Nightmare of the Nuclear Age. To WWII

Veterans, Dropping the Atom Bomb Saved U.S. Lives. Their Conflict over a Commemorative Exhibit Sparked the Museum's Retreat and a Bitter War of Words," *Los Angeles Times*, December 19, 1994.

32. Associated Press, "USA: Washington: *Enola Gay* Exhibition Causes Protests," *AP News*, June 28, 1995.

33. Historians have described these debates as less about *history* per se than about what is often described as *memory* or, more specifically, the widely held "collective memory" and "national memory" that binds a society together through a broadly agreed-on view of past events and their meaning. The historian Alon Confino reminds us, "Studies of conflict tend to reproduce on the symbolic level the social and political conflicts that are familiar from previous studies." He adds, "People construct representations of the nation that conceal through symbols real friction in their society. These representations should also be studied." Confino, "AHR Forum: Collective Memory and Cultural History: Problems of Method," *American Historical Review* 102 (December 1997): 1400.

34. For a very brief overview in context, Simmons, *Museums*, 226. Another summation of the significance of this event for students of history can be read in Sarah Maza, *Thinking about History* (Chicago: University of Chicago Press, 2017), 134–135.

35. Associated Press, "Controversy over the Display of the *Enola Gay*," *AP News*, December 15, 2003.

36. Risen, "For Two Smithsonian Curators."

37. Risen.

38. Kohn, "History and the Culture Wars," 1036.

39. Neil Harris, "Museums and Controversy: Some Introductory Reflections," *Journal of American History* 82, no. 3 (December 1995): 1102.

40. Harris, 1103, 1104.

41. Harris, 1102.

42. Fath Davis Ruffins, "Culture Wars Won and Lost: Ethnic Museums on the Mall, Part I: The National Holocaust Museum and the National Museum of the American Indian," *Radical History Review* 68 (Spring 1997): 82.

43. Harris, "Museums and Controversy," 1109–1110.

44. Simmons, *Museums*, 241.

45. Simmons, 234.

46. Newsroom for the Smithsonian, "Visitor Stats."

47. James Risen, "For Two Smithsonian Curators, the *Enola Gay*'s Mission Launched the Nightmare of the Nuclear Age. To WWII Veterans, Dropping the Atom Bomb Saved U.S. Lives. Their Conflict over a Commemorative Exhibit Sparked the Museum's Retreat and a Bitter War of Words," *Los Angeles Times*, December 19, 1994.

48. Newsroom for the Smithsonian, "Visitor Stats."

6. MUSEUM CRISIS IN RECENT HISTORY

1. Other individuals have connected these developments in important ways. Protests signs bore the slogan "Racism Is a Pandemic Too," for example, and medical professionals further drew connections between systemic inequalities in medicine and widespread racism in the United States. See American Psychological Association, "'We Are Living in a Racism Pandemic,' Says APA President," press release, May 29, 2020, www.apa.org. See also Terrance Smith, "Health Care Workers Say 'Racism Is a Pandemic Too,'" *ABC News*, June 12, 2020, https://abc7news.com; the article reads, "The protests against disparate ways in which blacks are treated and impacted by law enforcement also come at a time where the coronavirus pandemic is disproportionately affecting communities of color across the country."

2. American Alliance of Museums, "National Snapshot of Covid-19 Impact on United States Museums," survey fielded October 15–28, 2020, www.aam-us.org.

3. Stephen E. Weil, *Making Museums Matter* (Washington, DC: Smithsonian Books, 2002), 63.

4. For more on the influence of 9/11 on museums in New York City, see Amy K. Levin, "Business as Usual: Museums, Money, and 9/11 Memories," in *Defining Memory: Local Museums and the Construction of History in America's Changing Communities*, ed. Amy K. Levin and Joshua G. Adair (Lanham, MD: AltaMira, 2007), 271–292.

5. For more on September 11, 2001, and its lasting influence on public history, see James B. Gardner and Sarah M. Henry, "September 11 and the Mourning After: Reflections on Collecting and Interpreting the

History of Tragedy," *Public Historian* 24, no. 3 (2002): 37–52. See also Mary Marshall Clark, Peter Bearman, Catherine Ellis, and Stephen Drury Smith, eds., *After the Fall: New York Remembers September 2001 and the Years That Followed* (New York: New Press, 2011).

6. Jacqueline Trescott and Sarah Kaufman, "Cultural Activities Pause after Tragedy," *Washington Post*, September 12, 2001, C1.

7. "A National Tragedy: Terrorism Hits New York and Washington," *Washington Post*, September 12, 2001.

8. Quoted in Simmons, *Museums*, 259.

9. Trescott and Kaufman, "Cultural Activities Pause after Tragedy."

10. Amy K. Levin, "Business as Usual: Museums, Money, and 9/11 Memories," in Levin and Adair, *Defining Memory*, 272.

11. US Congress, House, Committee on Energy and Commerce, Subcommittee on Commerce, Trade, and Consumer Protection, *The State of the U.S. Tourism Industry*, October 17, 2001, 60.

12. Newsroom for the Smithsonian, "Visitor Stats."

13. American Alliance of Museums, "Security Network: Resources: US Department of Homeland Security," accessed June 10, 2021, www.aam-us.org.

14. Jen Kirby, "French Authorities Foil 'Imminent' Terror Plot against Paris," *New York*, February 10, 2017, https://nymag.com.

15. Sewell Chan, "New Orleans Museum, under Lock and Guard," *New York Times*, September 19, 2005, E1.

16. Chan.

17. Chan.

18. Chan.

19. John Whitaker, "Protecting Priceless Art from Natural Disasters," *Atlantic*, May 27, 2015.

20. Sarah Cascone, "One Million Artifacts Salvaged from Hurricane Sandy Return to Ellis Island," *Artnet News*, September 10, 2015.

21. Associated Press, "South Street Seaport Museum Opens 1st Post-Superstorm Sandy Exhibit," WABC-TV, March 18, 2016, http://abc7ny.com.

22. Whitaker, "Protecting Priceless Art from Natural Disasters."

23. Whitaker.

24. MoMA, "Hurricane Sandy: Conservation Resources," accessed June 10, 2021, www.moma.org.

25. Carol Vogel, "Museums Fear Lean Days Ahead," *New York Times*, October 19, 2008.

26. Vogel.

27. Carol Vogel, "Met Museum to Close Shops, Freeze Hiring," *New York Times*, February 23, 2009.

28. Elizabeth Blair, "As Museums Try to Make Ends Meet, 'Deaccession' Is the Art World's Dirty Word," National Public Radio, August 11, 2014.

29. Recent texts to take on the subject of deaccessioning include Steven Miller, *Deaccessioning Today: Theory and Practice* (Lanham, MD: Rowman and Littlefield, 2018); and Julia Courtney, *Is It Okay to Sell the Monet? The Age of Deaccessioning in Museums* (Lanham, MD: Rowman and Littlefield, 2018).

30. Blair, "As Museums Try to Make Ends Meet."

31. Robin Pogrebin, "Censured by Museum Association, National Academy Revises Its Policies," *New York Times*, March 13, 2009.

32. An early news article sounding the warning can be seen in Elizabeth Dwoskin, "In Bankruptcy, Detroit Could Sell Off Its Art Collection," *Bloomberg Businessweek*, June 4, 2013, www.bloomberg.com.

33. Lee Rosenbaum, "After Detroit's Close Call," *Wall Street Journal*, November 19, 2014.

34. I have written more about how museums swapped, loaned, and came to problematically compare collections in an article: Samuel J. Redman, "Impossible Appraisals: Art, Anthropology, and the Limits of Evaluating Museum Collections in the Mid-Twentieth Century United States," *Museum Review* 3, no. 1 (September 2018), https://themuseumreviewjournal.wordpress.com.

35. Vogel, "Museums Fear Lean Days Ahead."

36. A similar critique recently appeared in the *Los Angeles Times*. See Christopher Knight, "Commentary: While the Met Contemplates Selling Its Treasured Art, Rich Trustees Sit Idle," *Los Angeles Times*, February 14, 2021. "Selling art from the collection to pay the bills is tantamount to eating the seed corn. A museum's collection is the reason why it exists. But here comes the Met to tell us that, well, you know, sometimes things are so bad maybe you just gotta."

37. "Met Sees Attendance Surge as MoMA's Visitor Numbers Drop," *Artforum*, January 12, 2012.

38. Sara E. Wermiel, *The Fireproof Building: Technology and Public Safety in the Nineteenth-Century American City* (Baltimore: Johns Hopkins University Press, 2000).

39. David Biller, "Brazil Police Finish Investigation into National Museum Fire," *Washington Post*, July 6, 2020.

40. Kristin Lam and John Bacon, "Easy Fire Threatened Reagan Library, Burns 1,650 Acres: Fire Crews Reach 45% Containment at Kincade Fire," *USA Today*, October 31, 2019.

41. Lisa Lapin, "Getty Center Safe after Mass Efforts in Getty Fire, Now Reopened," *Iris Blog*, Getty Museum, November 2, 2019, https://blogs.getty.edu/iris/getty-center-safe-2019-fire/.

42. Nancy Kenney, "Museum of Chinese in America Starts Fund-Raising after Loss of Its Archive in a Fire," *Art Newspaper*, January 27, 2020, www.theartnewspaper.com.

43. Julia Jacobs, "After the Fire, a Chinatown Museum Sifts through What Survived," *New York Times*, March 23, 2020, C1.

44. Hakim Bishara, "Recovery Efforts Begin after Fire Ravages Museum of Chinese in America Archives," *Hyperallergic*, January 27, 2020.

45. Kenney, "Museum of Chinese in America Starts Fund-Raising."

46. United Nations, "Covid-19 Crisis Closes 90 Percent of Museums Globally: UNESCO Plans for Reopenings," May 18, 2020.

47. Ted Loos, "Class Is in Session Everywhere Now," *New York Times*, April 23, 2020.

48. Deirdre Paine, "Smithsonian Prepares for DC's Reopening with COVID-19 Response Team," *DC Post*, May 28, 2020, https://thedcpost.com.

49. Internationally, the Louvre's push to complete renovations during pandemic shutdowns captured the most attention. See, for example, Liz Alderman, "Mona Lisa Is Alone, but Still Smiling," *New York Times*, January 26, 2021. Sébastien Allard, the museum's general curator and director of the paintings department, is quoted as stating, "For some projects, the lockdown has allowed us to do in five days what would have previously taken five weeks." During the lockdown, 250 conservators, curators, and other staffers were estimated to be working at the museum.

50. Paine, "Smithsonian Prepares for DC's Reopening."

51. Nelson-Atkins Museum of Art, "Tux & Tiny Tails," accessed June 10, 2021, https://nelson-atkins.org.

52. Nelson-Atkins Museum of Art, "Penguins Visit Nelson-Atkins Ahead of Kansas City Opening," YouTube, May 14, 2020.

53. Nancy Kenney, "AAMD Loosens Rules for Museums Seeking to Divert Income amid Coronavirus Crisis," *Art Newspaper*, April 15, 2020.

54. Robin Pogrebin, "Brooklyn Museum to Sell 12 Works as Pandemic Changes the Rules," *New York Times*, September 16, 2020.

55. Farah Eltohamy, "The Met Considers Selling Its Art to Stave Off Financial Shortfall," National Public Radio, February 22, 2021.

56. See Mabel O. Wilson, *Negro Building: Black Americans in the World of Fairs and Museums* (Berkeley: University of California Press, 2012); and Andrea Burns, *From Storefront to Monument: Tracing the Public History of the Black Museum Movement* (Amherst: University of Massachusetts Press, 2013).

57. The legacy of this installation is noted in Domenick Ammirati, "Taste Venues," *Art in America*, December 1, 2018, www.artnews. com. I thank the art historian Gloria Sutton for making me aware of this installation.

58. "Return of the Whipping Post: Mining the Museum," *Underbelly*, Maryland Historical Society, October 10, 2013.

59. White House, Office of the Press Secretary, "Remarks by the President at the Dedication of the National Museum of African American History and Culture," press release, September 24, 2016, https://obamawhitehouse.archives.gov.

60. See, for example, Sarah Cascone, "The Museum Heist Scene in 'Black Panther' Adds Fuel to the Debate about African Art Restitution," *Artnet News*, March 5, 2018; and Lise Ragbir, "What *Black Panther* Gets Right about the Politics of Museums," *Hyperallergic*, March 20, 2018.

61. The scholar and former museum curator Steven Lubar further notes of this sort of self-reflexivity, "There's a long history of artists making art of museums exhibitions." Lubar, *Inside the Lost Museum: Curating, Past and Present* (Cambridge, MA: Harvard University Press, 2017), 325.

62. The title of this section is a nod to a now classic museum text, featuring dozens of essays on museum studies: Gail Anderson, ed., *Reinventing the Museum: The Evolving Conservation on the Paradigm Shift* (Lanham, MD: AltaMira, 2004).

63. White House, Office of the Press Secretary, "Remarks by the President."

64. For more along these lines, see Bill Adair, Benjamin Filene, and Laura Koloski, *Letting Go? Sharing Historical Authority in the User-Generated World* (London: Routledge, 2011).

CONCLUSION

1. In an editorial arguing that government leaders should be more imaginative in thinking about possible future crisis episodes, the scholar J. Peter Scoblic writes, "If an emergency isn't resolvable in the short term, it can be counterproductive to characterize it as one. It is not—or not only—a crisis. It is a condition." He adds, "Policymakers tend to see the present and the future as locked in a zero-sum time war, where attention to 'later' reduces attention to 'now,' and vice-versa. The present almost always wins, because the gains from success—and the costs of failure—are immediate and concrete. By contrast, the consequences of not adequately managing the future are far-off, uncertain and abstract. . . . Crises only magnify this dynamic, making the present loom even larger than usual." Scoblic, "We Can't Prevent Tomorrow's Catastrophes Unless We Imagine Them Today," *Washington Post*, March 18, 2021.

2. Simmons, *Museums*, 225–226.

3. Metropolitan Museum of Art, "Met Museum Sets New Attendance Record with More than 7.35 Million Visitors," press release, July 5, 2018, www.metmuseum.org.

4. American Alliance of Museums, "National Snapshot."

INDEX

ABOUT THE AUTHOR

Samuel J. Redman is a historian and former museum professional. He teaches modern US history at the University of Massachusetts, Amherst. He lives in Northampton with his son, Owen.